iPhoneography PRO

TECHNIQUES FOR TAKING YOUR IPHONE PHOTOGRAPHY TO THE NEXT LEVEL

Robert Morrissey

AMHERST MEDIA, INC. ■ BUFFALO, NY

Published by:
Amherst Media, Inc.
P.O. Box 586
Buffalo, N.Y. 14226
Fax: 716-874-4508
www.AmherstMedia.com

Publisher: Craig Alesse
Senior Editor/Production Manager: Michelle Perkins
Editors: Barbara A. Lynch-Johnt, Harvey Goldstein, Beth Alesse
Associate Publisher: Kate Neaverth
Editorial Assistance from: Carey A. Miller, Sally Jarzab, John S. Loder
Business Manager: Adam Richards
Warehouse and Fulfillment Manager: Roger Singo

ISBN-13: 978-1-60895-711-8
Library of Congress Control Number: 2015931596
10 9 8 7 6 5 4 3 2 1

www.facebook.com/AmherstMediaInc
www.youtube.com/c/AmherstMedia
www.twitter.com/AmherstMedia

Contents

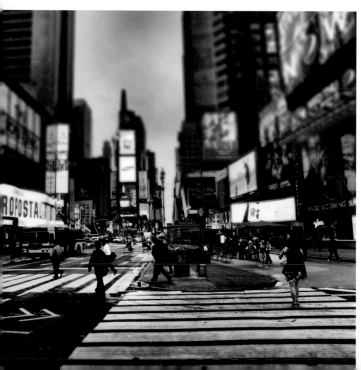

Preface

This book has been close to two years in the making. It has had its ups, downs, and run-arounds. For me, it has been an amazing journey into my own photographic process.

When I began this journey, I had three major misconceptions about the iPhone camera:

1. I thought that the iPhone's built-in camera was simple.
2. I expected the camera to react like my DSLR.
3. I did not expect the iPhone camera to have a wide-ranging impact on photography, around the globe.

First, the iPhone camera is a sophisticated device with integrated controls that make it easy for nonprofessional photographers to take great photos. The camera works great "out of the box," but there are a plethora of unique apps on the market, offered from countless companies worldwide, that you can download to supercharge your photographic options. With a trip to the App Store, you can collect apps that allow you to add creative color effects, simulate vintage film looks, add blur, and more. With a swipe of your thumb across your iPhone screen you can make your photo look like it was taken 10, 20, 30, or even 100 years ago.

No, the iPhone's camera doesn't work like my DSLR—but the manufacturers didn't want it to. Sure, there are apps avaialable for purchase that will give your iPhone camera DSLR-level functionality, but the truth is that iPhone camera is more flexible than your DSLR. Now, I am not saying that the iPhone camera is *better* than my DLSR. Quite the contrary, actually. The resolution the iPhone produces, however amazing, does not compare to my pro DSLR. But that's the thing—this camera is *different* from the DSLR, it's like a new toy that is fun to use and takes cool photos. It allows the general user to produce good photos with ease.

iPhoneography has resulted in a surge of artistic image sharing across the globe. Images can be shared almost instantaneously. The amazing thing is, many of these camera-phone images are *good*. Users almost seem to be in competition with one another to share photos that show evidence of mounting skill. We can have immediate access to important news events and/or family outings. We can take good photos, run them through apps, and make them amazing—without all of the rigors of professional training.

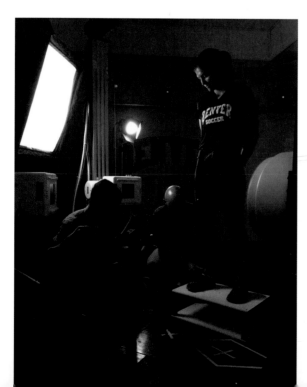

◄ Here is a Morrissey & Associates crew member on location during a video production shoot. The iPhone camera is great for capturing "day in the life" photos.

▲ This composite was made using three different apps—MegaPhoto, lo-mob, and the iOS 7 camera app. When you have a library of apps at your disposal, your means for artistic expression are multiplied. These images were taken with my iPhone 5 and iPhone 6+. They were merged together in Photoshop. Photos by the author.

About This Book

As a professional photographer, I don't see the merit in teaching you how to use your iPhone to get ordinarily good photos. I want to teach you how a *professional* would use the iPhone camera (or an iPad Mini or iPad). I want you to have the opportunity to examine the world in a different way. The information in this book will show you how to take your iPhone camera's abilities to the limit so that you can create images that most iPhone users would never create.

I know what my iPhone camera is capable of. I am past the point of being amazed that I can get a clear shot that will blow up to an 11x14-inch print with little or no grain. I am also beyond the point of simply aiming my camera at a scene or object and letting the iPhone do most of the heavy lifting. I am at the point of proving that the iPhone can create high-quality, artistic photographic portfolio images—creatively satisfying photographs that will generate income. This book will teach you how it's done.

Finally, I must point out that many shots in this book have been made more interesting with the use of Photoshop. Yes, there are plenty of shots in the book that will make the "iPhone purist" proud; however, I am a professional photographer. I am fortunate to make my living taking photos every day. As you grow as an artist, you will find that adding tools can help you achieve greater artistic expression. In some cases, you'll find that adding some postproduction enhancement will yield a stronger image than what you'll get right out of the camera. Think about it: You wouldn't use a butter knife to cut a steak if there was a steak knife right next to you, would you? My feeling is, I'd be a fool not to use my years of experience in Photoshop to make awesome images. In some of the lessons in this book, I will dissect the shot and show you how I used Photoshop to enhance the original capture.

For More Information

www.iPhoneographyPro.com
www.facebook.com/iPhonographyPro
www.morrisseyphoto.com

Introduction

When I was asked to write this book, I was a little skeptical about the quality and performance of the iPhone as a camera system. I had taken photos with every iPhone I'd owned, but I wasn't printing and framing them. I am a professional advertising photographer and the author of professional studio lighting books. I am used to having and using the best gear available.

I knew I would be able to teach people basic photography techniques that would make them better photographers. But as I dove deeper into truly understanding the iPhone as a camera, I discovered that, with proper apps, add-ons, and training, the iPhone can rival and replace a consumer-grade DSLR or digital point & shoot camera. (We'll return to this topic later in the book.)

Let me introduce myself. I would normally speak about myself and my career in the "About the Author" section, but in this book, I believe that information belongs in the introduction. My name is Robert Morrissey, and I have been a professional commercial photographer for more than 20 years. I am the author of *Commercial Photographer's Master Lighting Guide* (2nd edition; Amherst Media, 2014). I am sponsored by major companies in the photographic industry, including Olympus, Chimera, Dynalite, and Schneider Optics. I also have the privilege of being a Phase One Cameras featured photographer for several years. I have worked on advertising campaigns for the likes of Albertsons, Lockheed Martin, GE, and many other major companies. Over my career, I have run E6 laboratories developing 4x5 slide film and photographed government catalogs on 4x5 and 8x10 cameras. I was one of the first photographers in Boulder, Colorado, to shoot with large-format digital cameras.

If a professional photographer (someone who is paid for their photography and knows their equipment like the back of their hand) with accolades like mine finds shooting with an iPhone camera an exciting option for creating quality

▼ This image is one of my personal favorites. Why? Because it shows how I can use my high-tech iPhone camera to produce an image that looks like it was taken in the 1960s on Kodachrome film.

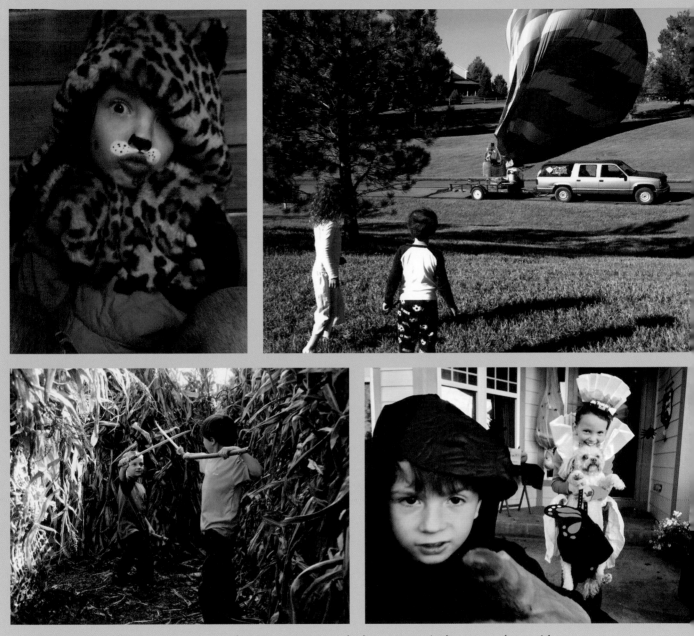

▲ When you simply want to capture and preserve moments, the best camera is the one you have with you.

images, then you can rest assured that you will be impressed with the results too.

In these pages, you will learn important lessons for creating technically strong images in a variety of genres, including fashion, portraits, products, food, landscapes, architecture, editorial, industrial, and medical. You'll learn how to best use your iPhone camera to get great results every time—even if you're just taking a few snapshots of your friends or family vacation— but the emphasis will be on using the iPhone in professional settings, with lights, lenses, and all the other tools available to the professional photographer.

Is the iPhone Camera for You?

As I see it, there are many benefits to using an iPhone camera. The camera takes great photos with less light than most cameras. You can compose, capture, and review photos on a large and surprisingly accurate display screen.

The iPhone itself is compact and lightweight, so it's easy to make sure that you always have a camera at the ready.

You can purchase great lens outfits for almost nothing (compared to professional photography lenses). With the right lens kits, the iPhone is fantastic for photographing extreme close-ups, cool fisheye effects, portraits, landscapes, products, sports, and more. With the iPhone, versus a DSLR, you have an array of filters at your disposal, all stored in memory once you download them. You don't have to carry around accessories to apply colored filter effects or other artistic enhancements. You can make your creative edits right on your phone.

Sharing your photos is simple. You upload your images to social media or deliver them via email (using Wi-Fi), more or less securely. You can print your photos quickly from any wireless printer and will usually get great results.

These benefits make using an iPhone camera a no-brainer. However, in fairness, there are a few things these cameras are not so good for. If you plan to create large prints of awesome

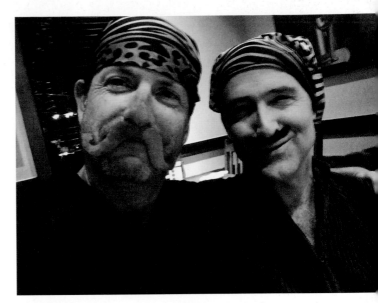

▲ This image was taken at my birthday party. It's a selfie of a friend of mine and me sporting pirate bandanas and fake mustaches. It was an important moment for me to remember and to pop on Facebook. The shot was taken with iOS 6 using the Apple camera. It is a little soft, but it allowed me to preserve and share the moment.

landscapes, photos of moving subjects, or want to shoot at night or in low light, the camera, out of the box, may not be your go-to choice. However, there are workaround apps and techniques that will help enhance your results (we will cover these topics later in the book).

My verdict is that the iPhone camera is a solid choice for many working photographers—maybe not for projects that have big budgets, elaborate sets, and models—but in a pinch it will surely do the job for portrait and family photographers and photojournalists.

You don't have to carry around accessories to apply colored filter effects or other artistic enhancements. You can make your creative edits right on your phone.

1. Create Great Images

An image (from the Latin word *imago*) is an artifact that reproduces the likeness of some subject—usually a physical object or person. Images may be two dimensional, such as a photograph, or three dimensional, such as a statue. In this book, of course, we will be discussing images captured by cameras—specifically, the iPhone camera.

An image shows a slice of the real world in a single static frame. Photographic images are everywhere. They are an important communication tool, and that communication is strengthened by strong photographic skills. There is no "good photo" filter on the iPhone—or any other camera for that matter. You must understand lighting, posing, composition, and all of the technical aspects that go into creating a well-exposed, well-executed shot. A good photograph requires more than a good camera, just as a pro basketball career requires more than a top-of-the-line basketball.

What Is a Bad Image?

In the world of consumer photography, we do not judge images the same way we would in the professional arena. Why would we? You are not trying to capture images and sell them or place them in ads. You are trying to capture your world as you see it, store your images, and share them with family and friends.

◄ Great image opportunities are everywhere. Using an iPhone makes capturing them easy.
► These images are different, but each is good in its own way. The first photo documents a moment in my life after photographing the Colorado Rapids pro women's soccer team. That's me with the team captain. The second shot is an artistic moment in time. It is available in my EyeEm Getty Images collection.

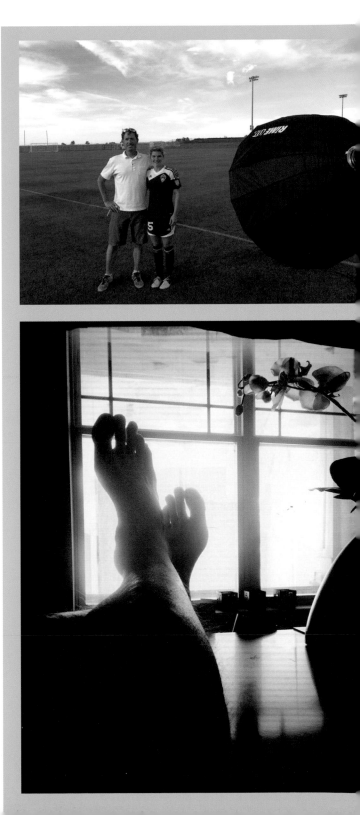

Don't do this!

▲ When I took this photo of a cool fountain in California, I didn't take the time to stand still. The lighting was insufficient for the older iPhone 3 camera. If I had held the camera properly, the result would have been better.

▶ A model used my iPhone to take this shot while I was taking photos. You can tell by the light traces that she didn't keep the camera still enough for it to adapt to the low light. You can barely tell what's going on.

Don't do this!

In the consumer realm, a bad image is a poorly rendered likeness of an object, person, or activity or one that fails to capture the moment. The image may be too blurry, too light, or too dark to see what is going on. You might think that if a good picture is worth a thousand words, a bad picture is worth one thousand bad words. The truth is, a bad photo is worth *one* word—"fail."

The two photos I have included here are perfect examples of images gone wrong. I want you to get a warm fuzzy feeling inside when you look at these images. You see, I am a professional photographer and even I can blow out an image to the point that it simply says "fail."

What Is a Good Image?

A good image conveys to the viewer a sense of completion and professionalism. This is where one thousand good words work in your favor. You are the hero who captured the moment, the creator of history, the sharer of great moments. You can rise in the morning knowing that you have done well and others will want to shake your hand. I may have gone too far, but hopefully you get my drift.

A good image doesn't have to be perfect. At the consumer photography level, a good image is one that captures the intended moment. That's it. This book was written to aid you in capturing these moments more accurately and more often. I want you to know how to overcome some of the main issues that all photographers face. By learning the lessons in this book, you will get better photos with your iPhone every time.

I have included a few images here that I consider to be good photos. They make the grade

because they capture moments in my family's history that I can see perfectly, store, and share. The exposure, cropping, and lighting may not be perfect, but they convey the intended moment and feeling.

Retouching: Making a Good Image Better. Most people prefer retouched photos, so long as the edits are not overdone. Once the illusion is obvious, the image can fall apart. I will not apologize for the fact that I retouch my images.

As a professional photographer, I am expected to understand what constitutes a perfect image and to take the steps required to deliver it. Many times, achieving that goal requires the use of some complex software. Yes, the best camera may be the one you have with you, and you can get great photos with your iPhone, but if you can enhance your results in postproduction, by all means, take advantage of whichever software program you favor.

▲ When you look at these two images, you can see several differences. The original photo was taken with my iPhone 5. It was a beautiful snowy day, and the whole family was out sledding. I may have gone too far when retouching my wife's beautiful face, but all in all she looks warmer and happier than she appears in the first image.

2. iPhoneography Gear

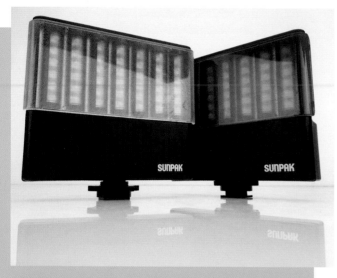

A photograph is 90 percent light and 10 percent subject matter. Light is the essence of all things photographic, and just a basic understanding of light will take you a long way on the journey to creating great photos.

LED Lights

Several companies make low-powered LED lights. These lights are relatively low-cost. However, to use them effectively, you may need to build an arsenal of grip gear (i.e., booms, stands, articulate arms, tape, poles, backgrounds, and more). My LED lighting kit for this book consists of three Rotolights (round) and seven SunPak lights (horizontal). Each light came with its own set of warming and diffusion filters. The Rotolights came with more filters, which can be stored within the unit itself. Very cool. The SunPak lights have a dimmer switch so I can effectively control the brightness of the light. The brightness of the Rotolights can be controlled through the use of neutral density (ND) filters. Each light uses AA batteries which will power the unit for a few hours. It is pretty cool to have ten battery-powered lights that

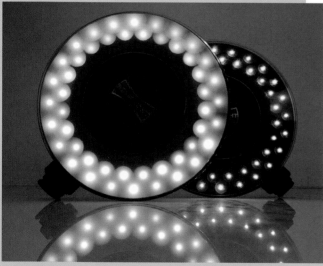

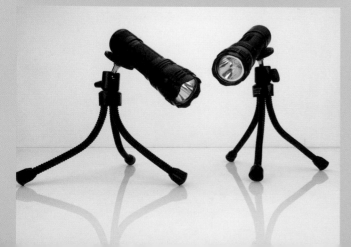

◀ *top*—This image shows the SunPak kit VL-LED 42. They come with a clear filter and an amber filter that can be easily mounted in front of the lights.
◀ *center*—This image shows the RotoLite RL48-B ring lights. They are a little better quality than the Sun-Paks. They come with filters that are stored inside of them when not in use.
◀ *bottom*—Here are a few LED flashlights on interesting little flexible tripod stands. The lights are narrow and can be used to add highlights to subjects/image elements that are already well lit. Also, the stands can be used with several other LED lights.

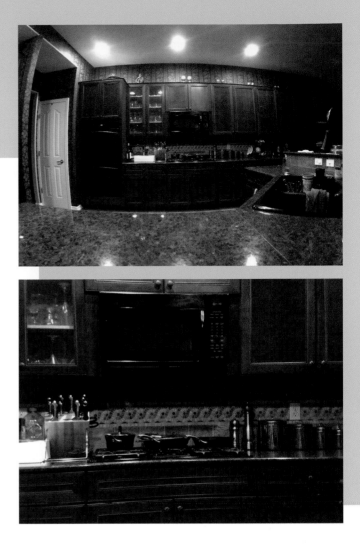

I can set up anywhere and not have to worry about electricity at all. These lights, along with the iPhone camera and lenses, make a complete location and studio setup.

Some of the lighting techniques that I will present in this book are complex. One of the advantages of working with LEDs is that they are a continuous light source—in other words, the light is always on. This makes it easy to see the effect that your lighting setup is having on your subject.

Lens Kits

Buying accessory lenses for your iPhone will supercharge your imaging options. Some of the images in this book were shot through the native iPhone lens. Others were made with lenses from one of two impressive accessory lens kits. Let's take a closer look.

Schneider Optics iPro Lens System. If you're not familiar with Schneider Optics, stop reading for a second and take a look into the company. They are one of the world's leading manufacturers of great lenses and have been for a long time. The iPro lens system includes a hardshell case that attaches to the body of the iPhone; on the case, there is a ring that accepts lenses, which can be easily attached and removed. When I popped my Schneider lenses onto my iPhone, I couldn't believe the results. They turned my camera phone into a high-quality camera. Some of my favorite images

have been created using the iPhone camera with these inexpensive lenses. They are small and easy to pack, and changing lenses on an iPhone is easier that changing lenses on a DSLR.

mCam Lenses. My other lens kit is more of a total iPhone conversion kit (for details on this, see the caption on page 18). The iPhone is housed in an aluminum casing that accepts interchangeable lenses (not just those made my mCam, but DSLR lenses, too! It's crazy!). It's a great choice for shooting still images and video. The mCAM is so durable it may be considered indestructible.

▼ Here are the four lenses in my iPro lens kit. The lenses pack up nicely. Even with the case on my phone, it easily fits in my pocket. It can be used hand-held or mounted on a tripod.

▶ *top right*—See what I mean when I say this case is a complete conversion kit? This system allows for interchangeable lenses, has adapters for mounting third-party lenses, and offers a protective housing (I find it a little bulky for daily use and think it hampers my ability to use the iPhone as a phone).

▶ *bottom right*—This articulate arm is great. You can use it to hold your camera or your lights.

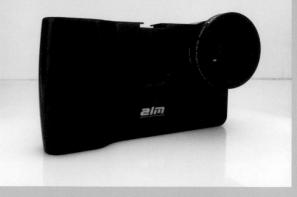

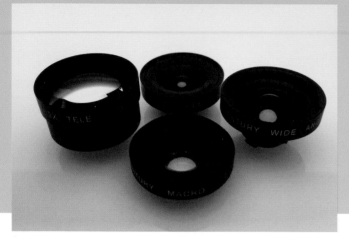

Accessory Lenses and Low-Light Shots. The iPhone is more flexible than your DSLR when you are working in challenging low-light scenarios. (*Note:* We're talking low light, not night photography—the iPhone, like many other digital cameras, still has a way to go when it comes to shooting at night; I recommend shooting film when you need professional-quality nighttime shots.) With accessory lenses, you can take a photo of someone with just the light of a lamp in a dark room and get a good, creative, focused shot. You can use filters to adjust colors and style for maximum results with little effort—and you can view your results on your iPhone screen as you go. I sometimes wish my pro cameras were so simple.

When you find yourself faced with shooting in a location with a low ambient light level (e.g.,

under low-wattage room lights or in fading sunlight), you can augment the existing light with your LED lighting unit(s). For the best results, choose a lens from the mCAM or Schneider lens kit, place your iPhone on a tripod, frame your subject, and start lighting like mad.

A Winning Combination: LEDs and Accessory Lenses. Investing in an accessory lens kit and LEDs has afforded me the ability to produce full-page shots for ads in major magazines. The resolution was fantastic and the images were available to the client almost instantly. I'd not be surprised to hear that pros with top-notch gear begin to lose gigs to folks with an iPhone, LEDs, and a good accessory lens kits. The results are that impressive.

Digital Filters

A digital filter is software that is applied in-camera to replicate an effect traditionally created using analog ("hardware") filters—but that's just half of the story. Digital filters can also impart effects that were never before possible. We are not talking about the filters used in postproduction, through programs like Adobe Photoshop. We're talking about adding effects in real time, as you shoot.

Digital filters are available in many apps (go to the App Store and enter "photo filters" to browse through the many options). My all-time favorite shooting app is called 645 Pro MK III. It offers controls like those found on most professional cameras. (We'll take a closer look at the many features this app offers later in the book. Here, we'll just investigate its filter options.) 645 Pro MK III has a large library of old-school filters that you can instantly apply to your images. You can change the intensity and color volume of the filter and preview the effect.

Be judicious in your use of filters. Sure, there are endless options out there that will allow you to add interesting effects to your images, but your goal should be to produce a clean, artistic image made in good taste.

A digital filter is software that is applied in-camera to replicate an effect traditionally created using analog ("hardware") filters—but that's just half of the story.

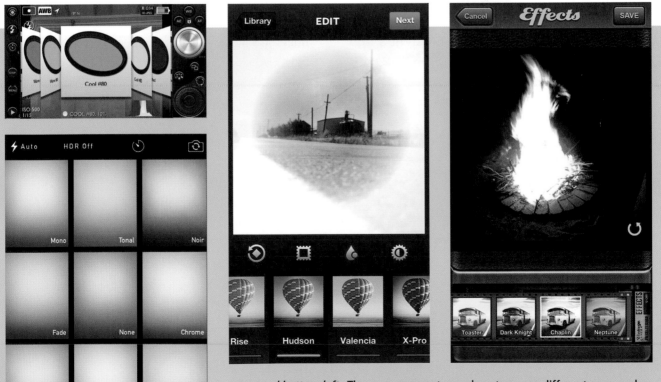

◄ *top and bottom left*—These screen captures show two very different approaches to the way digital filters can be applied. First is the app 645 Pro MK III for the iPhone, and the second is native to the iPhone 5 with iOS 8.1.3.

▲ *above left and right*—Some digital filters mimic effects that were once only available with analog filters. Other digital filters produce digital effects that take things to a whole other level. The blurred depth of field option is available through the Instagram app.

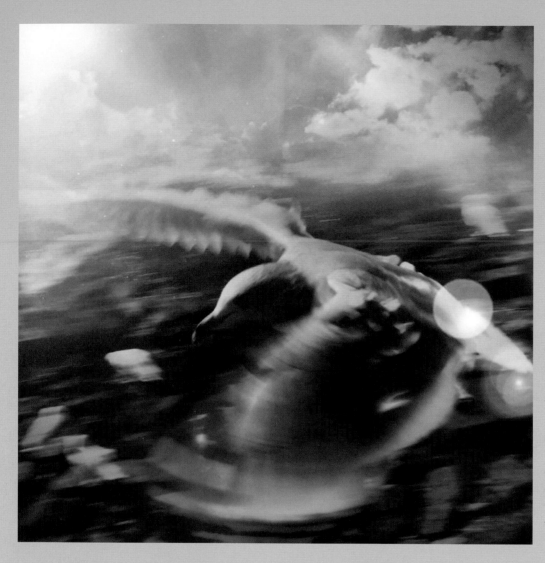

◄ To create this final image, I took a photo of a bird (which I tracked while shooting the iPhone in burst mode), then added the clouds and the sunburst were added in the Filter Mania 2 app.

Gear Used to Create the Images in This Book

Here is the master list of everything I used to create the images in this book. It's not much in comparison to the gear I used to create the photographs that appear in my commercial lighting book. You can get everything on this list for about $1500.00.

Cameras and Lenses
iPhone 3
iPhone 5s
iPhone 6
iPro Lens Kit by Schneider
 Telephoto lens
 Wide-angle lens
 Super-wide-angle lens
 Macro lens
mCam by Action Life Media
 Wide-angle lens and adapter

Lighting
Five Rotolights with filters
Bogen light stands

Matthews boom stands
Three small round makeup mirrors
White foam bounce cards
Gray foam bounce cards
Tripod

Apps
IOS 7 or 8 camera
iPhoto (with iOS 7)
FishEye
True HDR
Auto Bracket
Darkroom
ProCam
LongExpo Pro

Night Modes
EyeEm
645 Pro MK III
Dropbox
Instagram
Big Photo
MegaPhoto
Tadaa

Computer Software
Adobe Photoshop

3. Operating Systems

Your iPhone is an amazing device, and its awesome 8-megapixel camera produces great still images and video. You have features like auto focus and tap to focus. You can take still photos while recording 1080i HD video. You have the ability to take HDR (high dynamic range) photographs and to shoot panoramas. You have an on-camera flash that you can set to auto or use manually. Once you take the photos you can share them online, edit them in your digital software, or print them at your local lab. I have to say, this is pretty amazing.

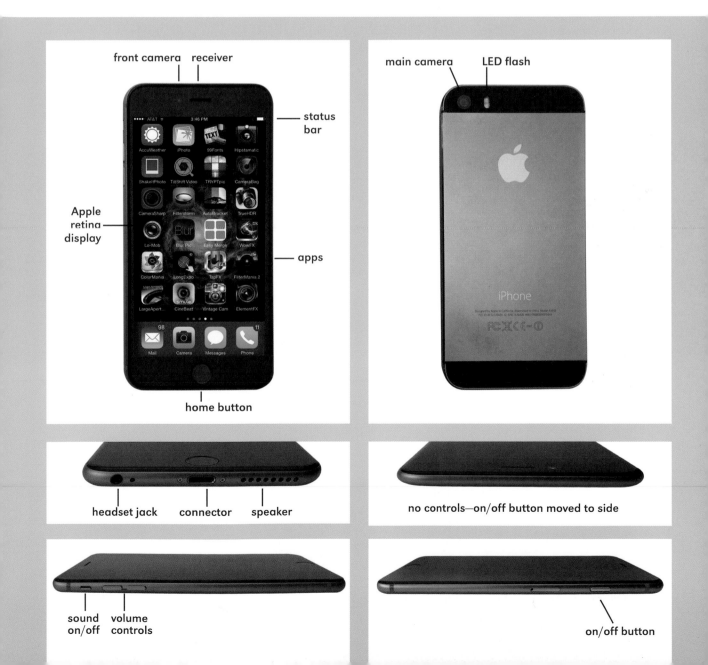

iOS 6 iPhone Camera Layout

If you are still using iOS 6, your iPhone screen will look much like this (image 1). While several of the photo functions mentioned in this book are only available in iOS 7 or iOS 8, you can still take great shots without updating your software. In fact, this book contains photos that date back to the iPhone 3.

In image 2, we see a vertical view of the screen. You can choose to take a photo (bottom center), access the camera roll (bottom left), choose from camera or video (bottom right), turn the flash on/off (top left), access options (top middle), or rotate the camera toward you. The center is the viewing screen.

Here's the horizontal view of the screen (image 3). You have the same options that are available with the camera in the vertical orientation, but the icons move to the right side of the viewing screen.

Tap the flash icon in the upper-left corner to access the flash options (image 4). Tap the Options button to access the Grid, HDR, or Panorama options (image 5). Slide the button to the right to activate the HDR function (image 6). "HDR ON" appears at the bottom center of the screen when the HDR option is selected (image 7).

Your screen will look like it does in image 8 when you select the Panorama option. As

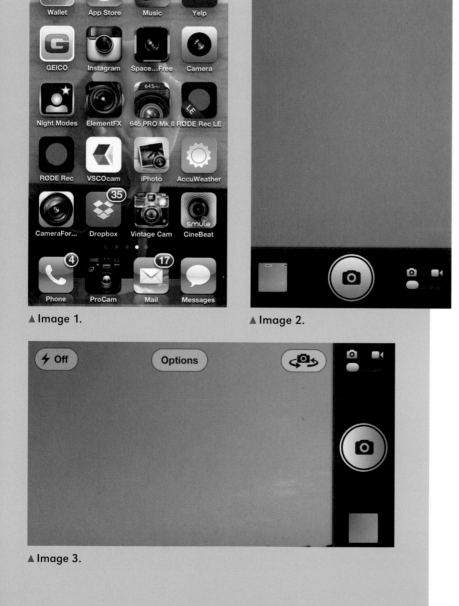

▲ Image 1.

▲ Image 2.

▲ Image 3.

Slide the button to the right to activate the HDR function. "HDR ON" appears at the bottom center of the screen when the HDR option is selected.

▲ Image 4.

▲ Image 5.

▲ Image 6.

▲ Image 7.

Move iPhone continuously when taking a Panorama.

▲ Image 8.

▲ Image 9.

▲ Image 10.

Camera Roll

▲ Image 11.

you pan (move your camera across the scene), you must keep the arrow on the line by tilting the camera slightly front and back. Try not to rotate the camera left to right.

With the button in the lower-right corner of the screen moved under the video icon, the camera is in video mode. In the lower-left corner, you can see the last photo taken and added to the camera roll (image 9).

In image 10, the camera is still in video mode; however, I selected the rotate camera option. Now the camera's lens "points to" the user/photographer. This makes it possible to take self-portraits (commonly called "selfies").

The camera roll (image 11) is your viewer; it allows you to access the image files stored in your phone.

iOS 7 iPhone Camera Layout

The iOS 7 software update provided much-needed enhancements to the camera functionality. If you're using iOS 7, your phone's screen will look much like it does in image 13.

Image 14 shows the icons used to access standard iPhone camera controls. You can access the photos stored on your phone by tapping the camera roll icon (bottom-left corner of the screen). Tap on the filters icon on the right to access filters. The button at the bottom center of the screen is pressed to capture an image.

Simply tap the flash button at the top left of the screen to choose amongst the flash options. Activate the HDR feature by tapping HDR at the top center of the screen. Finally, you can take self-portraits by turning the lens toward you. This is done by pressing the rotate-camera icon at the top-right corner of the screen.

Note: When the camera is held horizontally, the icons that appeared at the top of the screen in vertical mode move to the left. Those that were at the bottom of the screen when the phone is held vertically will appear on the right side of the screen.

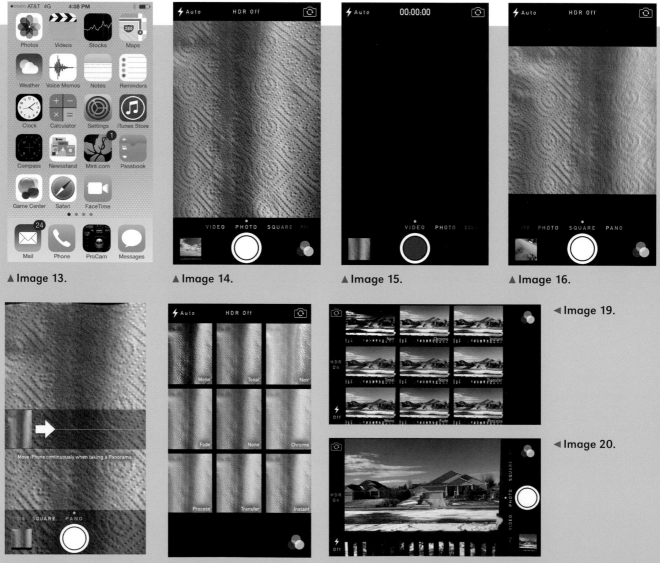

▲ Image 13. ▲ Image 14. ▲ Image 15. ▲ Image 16.

◄ Image 19.

◄ Image 20.

▲ Image 17. ▲ Image 18.

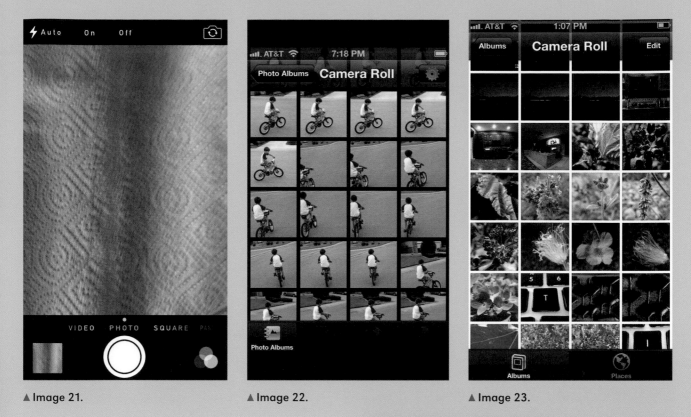

▲ Image 21. ▲ Image 22. ▲ Image 23.

The iPhone allows you to capture images in a range of formats. You can choose to take videos (image 15), square photos (image 16), or panoramic photos. In panoramic mode, remember to hold the camera straight up and down to keep the arrow on the line (image 17).

Image 18 shows the different color modes in which you can capture your photos. This has got to be the best addition to any app. If you don't like the effect, you can change it in the edit mode.

Image 19 shows the screen on which you can choose filter effects prior to taking the image.

The next two screen shots show the HDR option on (image 20) and off (image 21).

The camera roll (image 22) shows all of the images stored in your photo library. Make sure you sync all of your other camera apps to your camera roll, or things can get confusing fast.

▲ Image 24.

Image 23 shows the screen that allows you to access your photo albums and favorites. You can also select photos and edit them.

Once you select the image from the filters mode, you can preview the effect and take the photo (image 24).

iOS 8 iPhone Camera Layout

In iOS 8, you now have a timer option. At the top of the screen (see image 25), you'll see a clock icon. Touch it to access the timer options.

iOS 8 offers a time-lapse feature (image 26). You will need to keep the camera steady for the desired results. In image 27, you can see the time-lapse counter ticks away while shots are taken. The shots are compiled into a movie and stored in your camera roll.

In iOS 8, you can apply one of eight filters to your images while taking photos (image 28).

In iOS 8, the edit options are better than ever before. Image 29 shows a photo that has been chosen from the camera roll.

In iOS 8, you can also touch the heart icon to mark your photo as a Favorite (image 30).

When you press the word Edit (image 31), you are presented with some great options. In the upper-left corner of the screen, you will find the red-eye reduction tool. In the upper-right corner, you'll see the auto-adjustment icon. The three icons at the bottom of the screen (left to right) allow you to crop the photo, apply filters, adjust the lightness/contrast (this allows for a black & white effect). If you opt to leave the original image as is, simply press Cancel.

Image 32 shows that tapping the auto-adjustment icon enhances the colors and contrast in my image. If you don't approve of the changes,

▲ Image 25. ▲ Image 26. ▲ Image 27. ▲ Image 28.

▲ Image 29. ▲ Image 30. ▲ Image 31. ▲ Image 32. ▲ Image 33.

▲ Image 34.　　▲ Image 35.　　▲ Image 36.　　▲ Image 37.

▲ Image 38.　　▲ Image 39.　　▲ Image 40.　　▲ Image 41.　　▲ Image 42.

click the tool a second time or click Cancel, then Discard Changes.

In iOS 8, you can crop or rotate your photo (image 33). Here, I touched the icon of the square with the curved arrow to rotate the image 90 degrees. You can rotate the image freely by clicking on the numbered dial below the image. The crop screen (image 34) shows an icon of multiple squares. When you tap on it, you can select from various aspect ratios for your image.

Tap the filters icon (image 35) to access various filter effects. Here, I chose Mono. Tap on the icon that looks like a dial (image 36), and you'll see additional editing options.

If you tap the word Light, you can scroll through brighter or darker exposure options (image 37). In the upper-right corner of the Light screen, you'll see a list icon. Tap it for more exposure-adjustment options (image 38).

Tap on the word Color to adjust the overall color in your shot (image 39). Here, too, you

▲ Image 43. ▲ Image 44. ▲ Image 45.

Tap B&W to adjust the overall color in your photo. Here, too, you can tap on the list icon for more options for refining the black & white effect.

can tap on the list icon for additional color-refining options.

Tap B&W to adjust the overall color in your photo (image 40). Here, too, you can tap on the list icon for more options for refining the black & white effect (image 41).

In iOS 8, I can select the ellipses icon (three dots) to access options from compatible apps (image 42). This means I don't have to move between apps to try out different looks.

Here, I tapped on the ellipses icon (three dots) to access options from the TaDaa app. (I changed to an image of a fish because I'd seen enough of the jellyfish!) See image 43, image 44, and image 45.

4. Apps to Control Camera Functions

There are many third-party apps available in the App Store that are designed to turn your iPhone's camera into a feature-rich device. With these apps and a few Schneider iPro lenses, you can turn your iPhone camera into an amazing fit-in-the-pocket camera that rivals a DSLR.

For ultimate control over your image making, you will want an app that allows you to control the camera's shutter speed, ISO, and f-stop. The ability to control the dimensions of the image frame and add color filter effects is a big plus.

Each of the apps discussed here offers something a little different. I don't think that there is a single app out there that covers it all; you may need several apps to run your camera the way you like. I have a few favorite apps and use them when they suit my needs. I have tried each app listed here and heartily recommend them. They are the real deal.

645 Pro MK III

Image 1 shows the main screen of the app. You have access to the same controls offered on a real 645 camera. The app even offers a histogram that you can use to check your exposure. The second screen shot (image 2) shows the options inside the app.

This has to be one of the most advanced camera apps on the market. The options are amazing, but to use them successfully, you will need to have a firm understanding of the basic tenets of photographic technique. Tap on Menu to access the menu options shown in image 2.

The app also allows you to choose amongst filters that will apply traditional film effects. To access these, click on the first icon under the large silver shutter button, then swipe to rotate through the film options (image 3).

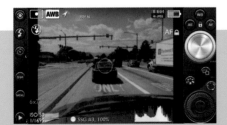
▲ Image 1.

▲ Image 2.

▲ Image 3.

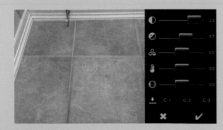
▲ Image 4.

▲ Image 5.

▲ Image 6.

▲ Image 7.

▲ Image 8.

▲ Image 9.

▲ Image 10.

When you choose the film type you want to emulate, note that there's an edit icon in the lower-right corner (see image 3). When you click on it, you'll be presented with sliders that will allow you to customize that particular "film." See image 4.

Image 5 shows the old-school filter options that can be applied to the image, in capture. This app has everything!

Want to create an image with an aspect ratio produced by older cameras? This app allows you to choose from 6x4.5, 6x6, 6x7 formats and more. See image 6.

ProCam

ProCam is a feature-rich app that allows you to make adjustments to your exposure and white balance. One of its strong suits is its ability to capture motion in multiple burst mode.

It offers a night-time mode and self-timers. (Image 7 shows a sample photo taken with the app.)

Image 8 shows the main screen of the Pro-Cam app. In image 9, I used the zoom handle and zoomed all the way into the scene. To date, this is the best app available for zooming in to "get close" to your subject or scene. In image 10, I used the zoom handle and zoomed all the way out.

▲ Image 11.

▲ Image 12.

▲ Image 13.

▲ Image 14.

7.0 MPX

This app is simple to use. To focus and take a photo, simply tap on the screen. This app is also great for capturing large image files. It has a pretty good zoom and offers self-timer and time-lapse options too. See images 11 and 12.

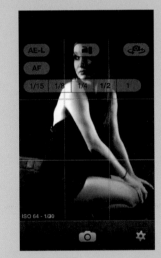

▲ Image 15.

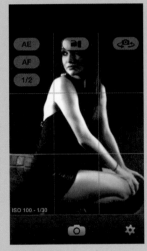

▲ Image 16.

▲ Image 17.

Vintage Camera

Vintage Camera is a cute app for the iPhone. It's lots of fun, and you won't suffer from dial or setting overload. See image 13.

LongExpo Pro

When you install this app, you can dial in long exposure times. This is helpful in low-light scenarios or when you want to blur moving subjects. See image 14.

Night Modes

Apps like this one allow you the option to use a slow shutter speed for long exposures. Image 15 shows the app's main screen. As you can see, you can choose various exposure durations. If you look in the top left of the screen, you will see that you have the options for auto focus and auto exposure. Image 16 shows the settings options. Image 17 shows self-timer options and the low-light boost option.

Camera Sharp

If you find that your photos are often out of focus due to camera shake (due to body movement), this app is for you. The camera will only capture images while it is completely still.

TaDaa

This is a powerful app that offers several filter-rich features and editing options that will help you take your images from good to amazing.

Camera 360

Here is another great app for applying filter effects while shooting. It's not as good as the filter effects in iOS 8, but the options available for capturing images are good.

Fisheye

Everyone needs a fisheye lens option for their iPhone camera. The app's main screen is shown in image 18.

Aviary

This is a magical app that allows you to create and share beautiful photos. It's helpful to have an Adobe account if you're going to use this app. Registering for an account is free and opens many doors to creativity.

Retrica

Retrica is a pretty interesting app. Most of the filters impart retro photographic looks to your images. You can preview the results before you snap the picture.

▲ Image 18.

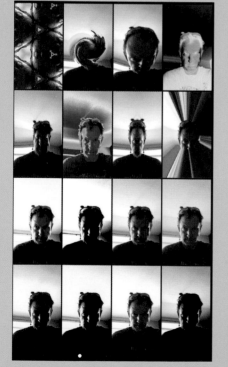

▲ Image 19.

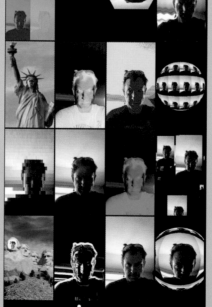

▲ Image 20.

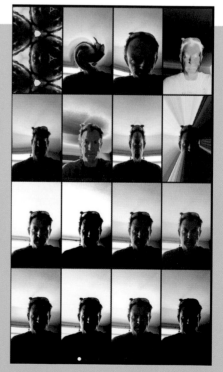

▲ Image 21.

▲ *left*—Here is a fun photo created using the MegaPhoto and TaaDaa. MegaPhoto allowed for the mirror effect, while TaDaa filters produced the glowing colors. The vibrance was increased in the iOS 8 edit mode.
▲ *right*—Here is a screen shot of a photo being edited in the Aviary app.

 ## MegaPhoto

This app offers lots of filter options. It's perfect for adding fun and wild effects to your images. Images 19, 20, and 21 show the many filter options available through the MegaPhoto app.

 ## CamWowPro

This app offers a handful of filters. It's perfect for simple image-enhancement options.

 ## Pixlr-o-matic

This app makes it easy to add effects, overlays, and borders to your images. You can easily create retro, grunge, clean, or stylish looks in three easy steps.

5. Best Practices

Hold Steady!

Proper technique will help you get better shots with crisper focus. Just as with any camera, if you are moving the camera while it's taking photos, you can end up blurring the photo. For the best results, use the approach outlined for holding the camera in the following ways:

Vertical. Remember that the lens is at the top-right corner of the camera when it is held in the vertical position. Use both hands when holding the iPhone in camera mode and press the "take photo" button with your thumb.

Horizontal. In the horizontal orientation, the iPhone's lens should be in the upper-left corner of the phone. Again, be sure to hold your iPhone with both hands when using the camera and press the "take photo" button with your thumb.

Above Your Head. When shooting from overhead, try to hold it above and in front of you so that you can view the screen and see what it is that you're capturing. If you're unable to see the screen, you may need to take the photo, then bring the phone down to eye level to view your results. Again, you'll want to hold the camera with both hands to keep the camera as steady as possible and use your thumb to press the "take photo" button.

Work That Shot!

Don't hesitate to move around, change locations, or even get in the way of others. Sometimes a little effort will get you the best photos. Most people will give you a moment to take your photo and go on your way. I have never had anyone be rude to me when I asked for a photo opportunity.

Panoramas. While holding your iPhone camera in panorama mode, remember not to twist the camera side to side. While holding the device with your bottom hand, use your top hand to tilt it forward and backward to keep the arrow on the screen on the line. This ensures the camera is level. Keep your arms out, elbows straight, and turn your body. You will be turning more than you'd think, so try to prepare for this prior to starting your shot.

Tripods. There are many accessories on the market that will allow you to mount your iPhone on a tripod. Tripods are perfect for landscapes, products, family portraits, and food photography, but using one can limit your ability to shoot using creative camera angles and can hamper your ability to capture spur-of-the-moment shots. I recommend using a tripod only if you are taking shots for which the camera must be perfectly still.

Understanding Light

When a pro photographer teaches you photography, you're sure to get extensive lessons on lighting. Sure, I can ramble on about apps and filters all day long—but filters and apps can only do so much for your photos. What makes a photo great is great lighting. Let's take a closer look at lighting.

Types of Light. Light is classified as natural or artificial. Natural light comes from the sun, whether it is the low light that filters into a shady area, direct sunlight that comes from a

▶ *top right*—In this image of my daughter walking through a maze of hay, there is strong light coming from the back right of the image. If I did not have a firm foundation in lighting and its effects, I probably would have wound up with an image with lens flare, which would have had a negative impact on the mood of the image. By preventing flare, I was able to preserve full detail in the shadows of the hay maze and on my daughter's face.

▶ *bottom right*—This modeling portrait was taken outdoors. I did not need any artificial light to get a great shot.

▼ This photo is a good example of professional lighting. This shot was taken with my iPhone camera. The image gets my message across clearly. If you don't understanding lighting, you will not reach your full potential as a photographer.

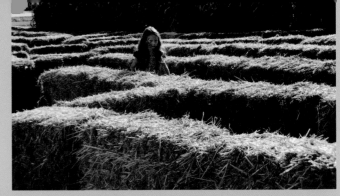

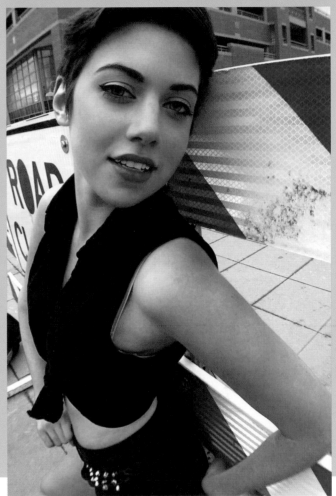

cloudless sky, or the light that refracts through the glass of a window to light an interior space. Artificial light comes from a man-made source. Photographers use both natural and artificial light of all types when creating images, and often these sources are combined with great results.

Natural Light. Natural light can create a variety of appealing effects, especially in portrait photography. Although studio lighting offers the ultimate in control, many photographers prefer the simplicity of working with natural light.

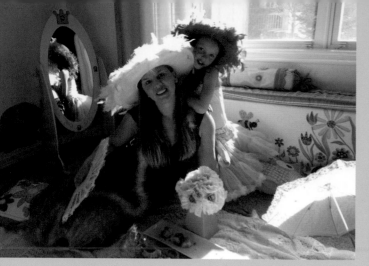

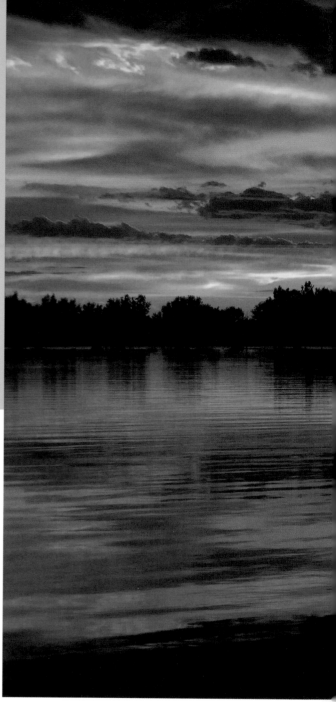

▲ This photo of my daughter and wife was given that perfect glow from the window light that was cast into the room. The light that comes through a window can be focused and bright; however, it disperses through a room quickly.

▶ This photo shows the beautiful effect of golden hour light.

It is best to avoid situations where the sunlight strikes the subject directly from above. Direct, overhead light can create unpleasant shadows on the face. Avoid this by shooting either earlier or later in the day when the sun is naturally at a lower angle. When you can, look for situations where the light is diffused and, if possible, blocked from overhead. The light at the edge of a clearing (with tall trees or branches overhead) is ideal, as is the light under the overhang on a porch. To re-create this diffused light effect, you can set up a 4x6-foot (or larger) scrim or sheet between two light stands. This will diffuse the light perfectly.

You can also use natural light indoors. Window light (or light through open doors) is often flattering for portrait subjects. Windows are often large, and the light is typically softened as it is transmitted through the glass. Windows, by their very nature, also produce light with good directional characteristics. For the best results when working with window light, place a reflector or bounce card opposite the sun to bounce light onto the shadow side of the subject. You can also soften or diffuse the light coming through a window with a diffusion scrim.

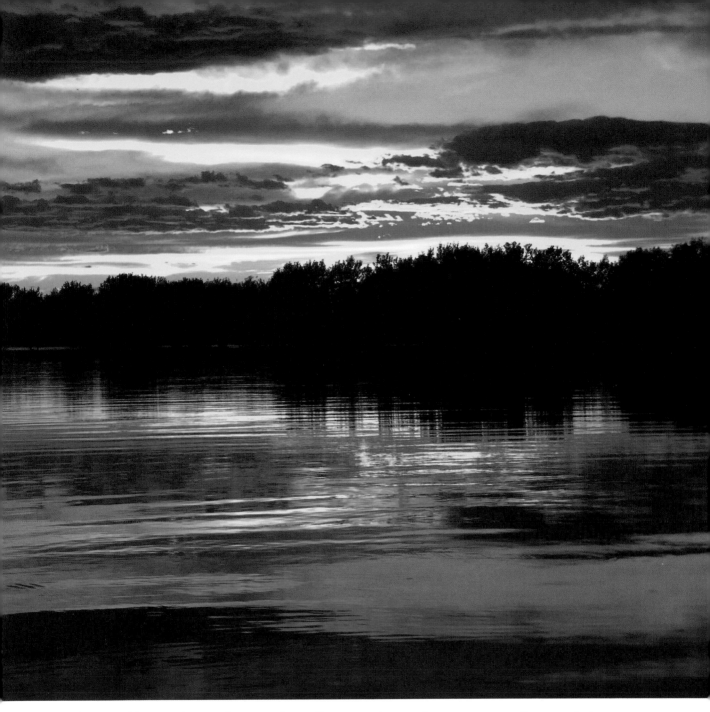

When working outdoors, photographers often prefer to take advantage of the golden hour, a time when the sun is low in the sky and can produce magically warm side and back lighting. The general rule is that the best light occurs from sunrise to one hour after sunrise and from one hour prior to sunset until sunset. I always show up one hour prior to sunrise or sunset in order to get my other lighting equipment, shot, subject, and props set up.

Artificial Light. When we consider artificial light, the same principles apply. If you light

your subject with a relatively small source (say, a bare bulb) from any distance, the light will be extremely hard. By adding a diffusion fabric in between the light and the subject (e.g., a diffusion panel or a white bedsheet), you are technically enlarging the light source. The light hits the fabric, travels the distance it can within that material, and leaves the material toward your subject, wider and softer than it was before.

Working with Available Light. When taking photographs in available light (any light in the scene that is not added by the photographer), it's important to consider where the light is coming from and to evaluate its qualities. For instance, if you are wanting to photograph your dog at the dog park at noon, then the sun will be directly above you. This means that the shadows from the sun will be cast downward. This tells you that the top of your dog will have the brightest sun and the underside will be in shadow.

Let's say you have the option to photograph your dog on the grass, on the sidewalk, and on the blacktop. Consider how the overhead light would react with these surfaces: the grass would soak up the light, the sidewalk would reflect the light up onto the underside of the dog, and the blacktop would conceptually cause the dog's underside to be rendered even darker. I'm not going to tell you there is a right way to photograph this dog. The choice you make depends on your artistic vision. When you understand how your light is impacted by your environment and use that knowledge to take complete control over the image-making process, though, you will be able to create images that meet your artistic ideals.

Now, let's say you are in a restaurant with good light overall. Perhaps there are several

▶ The only light in the scene came from the LED lights I brought with me. I waited for the sun to go down so that I could have complete control over the light illuminating the subject.

lights that are pointing at your subject from different directions. Prior to taking the photo, you look around and see that there is one area of the restaurant that is brighter than the rest; this is because there is a bright beer sign on the wall. You could move your subject closer to the sign and use the light from the sign to create warm glowing highlights on the subject's hair.

The Direction of Light. We've just reviewed the types of light that you will be working with. The next consideration that will affect your image outcome is where the light is coming from.

The direction of light is incredibly important to your image making. It determines where highlights and shadows will fall and it will impact the tonalities in the image. Light with a strong directional quality will create the appearance of a third dimension in photography; this effect is called "rounding" or "modeling."

The direction of light is usually described in relation to the subject, so moving either the light source or the subject can result in a change in the direction of the light. By changing the camera's perspective, you may include or exclude in your image more of the shadows and highlights created by the light.

In most cases, a light source illuminates the side of the subject closest to the light and leaves its opposite side in shadow. When extremely diffused light is used, the scene may lack definitive shadows, making the image appear too flat overall.

Front Light. Light coming from in front of the subject is called front lighting. With this

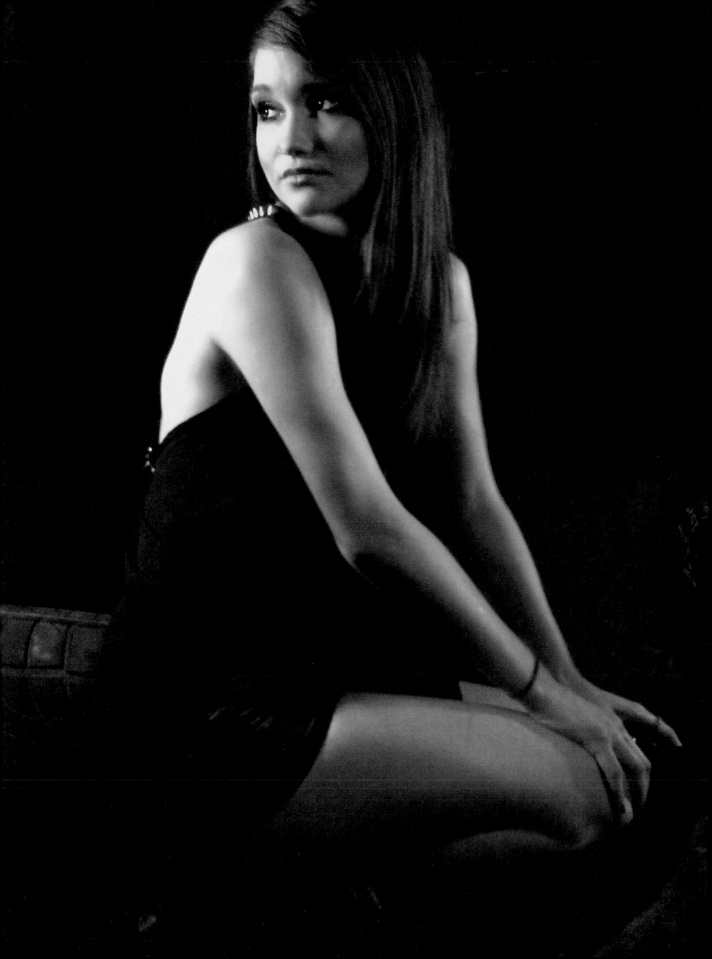

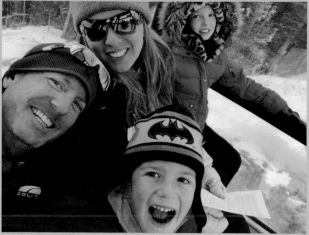

▲ Softened front light was perfect for this family portrait.

◄ Backlighting added a magical feeling of depth to this image of my daughter and me.

type of lighting, the detail on the front of the subject is well illuminated. As there may be only minimal shadow areas, the image may lack dimensionality and texture. This type of lighting is frequently used in fashion and glamour portraiture because it creates the appearance of smooth, flawless skin.

Front light can be hard or soft (we'll discuss these qualities in more detail a little later). Soft lighting is used to achieve an overall smoothness, while shadows cast by hard lighting creates a three-dimensional appearance in the image. (*Note:* Diffused front light will create a flattened or shallow depth in the image.) Many professionals combine hard and soft lighting to illuminate and sculpt their subjects.

Back Light. Back light is light that comes from behind the subject and toward the camera lens. This type of light often leaves the front of your subject in shadow and underexposed in the final image. It can also cause the edges of a subject to appear lit or seem to glow. When this effect occurs with back lighting, it is often called rim lighting. Back lighting is also used to create silhouettes.

Hair Light. A light that is placed over the subject to show detail in the hair is called a hair light.

Side Light. Side light, as you might suspect, originates at some angle to the left or right of the subject. This type of lighting can result in more pronounced shadows. As a result, it is common in portrait photography, where showing the shape of the subject's face is important to the image.

Overhead Light. Overhead light is exactly what you would expect—light that originates from some point above the subject's head. When you are working with studio lights, this source is usually held up by some type of boom stand.

Undercarriage Light. Undercarriage light comes from below the subject.

Many photo scenarios will require the use of side lights, overhead lights, front lights, and hair lights all in one shot. To carry out an effective lighting setup, you should understand the role of each light. Also, you should be able to "read" a photograph and deduce what types of lighting were used so that you can re-create any lighting effects that you find inspiring.

Hard Light versus Soft Light. Light can be characterized as hard or soft. The more diffuse the light, the softer it will be.

Hard light comes from a small, undiffused light source. A classic example of hard light is the light from the overhead sun when it is not diffused by clouds or an overcast sky. (Though the sun is huge, it is rendered relatively small as compared to the subject due to its extreme distance.) Hard light produces dark, hard-edged shadows, bright colors, and bright highlights. Think of the crisp, well-defined shadows that appear on a bright, sunny day.

Soft light is produced by sources that are large in relation to the subject (diffused). Taking the example of the sun again, imagine that you are standing outside on a very overcast day. If you can see your shadow at all, it will be pale and not very well defined (i.e., the edges will be soft and fuzzy). This is because the clouds have broken up the light and scattered it across the sky. On a day like this, the entire sky is the light source—and it's huge! As a result, the light is soft. Soft light produces paler, softer shadows (or no shadows at all) and more muted image colors. For most images, soft light is ideal.

When we consider artificial light, the same principles apply. If you light your subject with a relatively small source from any distance, the light will be hard. By placing a diffusion fabric between the light source and the subject, you are technically enlarging the light source. This could be a professional light modifier (like a panel) or something as simple as a large white bed sheet. The light now hits that fabric, travels through its thickness, then leaves the material toward your subject wider and softer.

It is also worth noting that the farther the light is from the subject, the less light there will be to make an exposure.

iPhone Flash. Flash is used for two main reasons—(1) to add light to any too-dark shadow areas on your main subject (e.g., when the sun is behind your subject so the background is bright but the subject/foreground is dark) and (2) to expose your main subject when there is just not enough overall light. It is also worth mentioning that you can use your flash to protect against common mistakes that photographers encounter all of the time.

Now that we have the basics down for available light, we get to move on to fill light using your iPhone's flash. (Technically, it is not a flash. The light on the iPhone is a high-powered LED that can assist lighting an object in some settings.) Once again, you need to identify what is happening on your image screen prior to taking your photo. Knowing when to use your flash will help prevent poor light issues and low-light issues, and stop blur most of the time.

Many photo scenarios will require the use of side lights, overhead lights, front lights, and hair lights all in one shot.

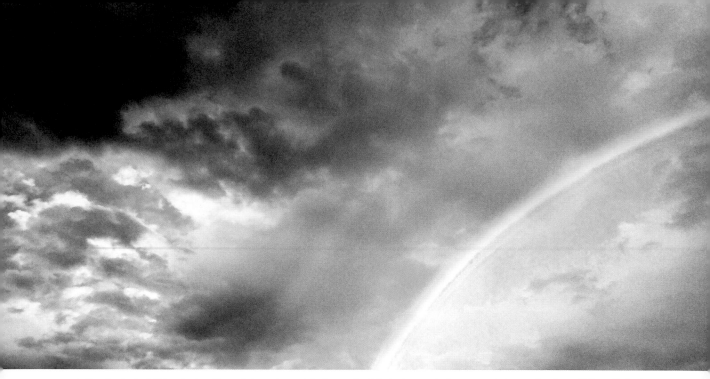

▲ I've included this photo of a rainbow to remind you that light is made from a rainbow of colors. When light is refracted through a prism, the colors of light separate. Light color shifts are also seen from man-made light sources like the different types of lightbulbs used in various settings.

But if you do not know how to use your flash properly, you can end up with photos that are overexposed and not worth keeping.

First, you will need to determine whether you are close enough to your subject to effectively add light with your built-in flash. You cannot light a concert stage from 500 feet away with an iPhone flash!

Second, is the situation so dark that the flash might only light the main subject? (If you are taking photos outside at night, your iPhone flash will only light whatever is within a few feet of the camera.)

Third, ask yourself whether or not you can add more light. Simply turning a light on can enhance your exposure and add overall ambiance to your photo. You would still use your flash, but the extra light can be a great boost to darker areas.

Fourth, are you too close to the subject? If you are too close to your subject when your iPhone camera's LED flash is turned on, your subject may squint. You could also overexpose your image if you are too close to your subject.

By considering these points, you will be on your way to a well-executed flash image.

Color Temperature. The light that we see is comprised of seven distinct colors: red, orange, yellow, green, blue, indigo, and violet. The human eye does a good job of balancing these colors, so colors look the same to us whether they are under reddish light (like at sunset), yellowish light (like a household lamp), or greenish light (like most fluorescents). Film and digital image sensors do not adapt as readily, and sometimes our images have a color cast. Some apps make automatic white balance adjustments at capture. Should you take an image and find that

there is an unpleasant color cast, you can use apps like DP Cam or TaDaa to correct the issue or simply edit the photo in iOS 8 photo editor.

Exposure. When working with DSLR cameras (or iPhone apps that allow users to manually select their exposure settings), you choose an aperture (lens opening; also called the f-stop), shutter speed, and ISO to precisely control the amount of light that will be allowed to strike the image sensor and create your image. In a correctly exposed image, there is a full range of tones and detail can be seen in the brightest and darkest tones. In an overexposed image, the tones are too bright and the subject and scene appear washed out. In an underexposed image, the tones are too dark and the colors may appear muddy. You can simply gauge the exposure in your image by studying the tones in your image or you can look at the way the tones are distributed on a histogram.

A histogram is a graph that charts the tonal distributions in an image, from pure white to pure black. In an overexposed (too bright) image, the majority of data will be piled up at the highlight edge of the graph. In an underexposed image (too dark), the majority of data will be piled up at the shadow edge of the graph. The histogram for a well-exposed image will contain data across the length of the graph. For the average correctly exposed image, the histogram's data will peak in the center area.

The iPhone provides some simple tools to adjust the exposure in your image.

Metering Light. Light Meter–Lux and myLightMeter PRO are two of the many apps available in the App Store that will measure the light output in a given scene and calculate the f-stop, shutter speed, and ISO settings required to achieve a correct exposure.

Color Temperature Chart

Light is described in degrees Kelvin. The lower the color Kelvin degree rating, the warmer the light is in color. The higher the Kelvin degree rating, the cooler the light is in color. Below is a list of the temperature ratings of common light sources.

match flame 1700–1800K
candle flame 1850–1930K
sun (at sunrise or sunset) 2000–3000K
household tungsten bulbs 2500–2900K
tungsten lamp (500W–1000W)–3000K
quartz lights 3200–3500K
fluorescent lights 3200–7500K
sun, direct (at noon) 5000–5400K
daylight 5500–6500K
overcast sky 6000–7500K
computer monitor 6500K
outdoor shade 7000–8000K
partly cloudy sky 8000–10,000K
iPhone's LED flash 4500–5250K

Posing Techniques

Individuals. When posing women, there is a great deal of room for creativity. Aim for a pose that is flattering and looks natural when working with most female subjects. You might find that asking a subject to lean against something, raise an arm, or even spin around and look at you results in a flattering look.

When you are photographing men, avoid any poses that have a feminine look. For a casual and believable pose, you can ask male subjects to put their hands in their pockets with their thumbs out, cross their arms, or squat down and look up at the lens.

Groups. Some people assume that you can point your iPhone camera, tap the screen to focus, and the people in the photo will look great.

iPhone Camera Exposure Zones

When using your iPhone camera, you can control the exposure of your image with a single touch. All you need to do is touch the area of the image that you want perfectly exposed.

Think of your image as being comprised of three zones. The bright zone is the brightest part of the image frame. The middle zone contains the midtones. This is the part of the image with the best color saturation. The dark zone is the darkest part in the frame. If your image is too dark, press on the darkest portion of the photo. The camera will adjust the exposure for that darker zone. This will give you good exposure in the dark and middle exposure zones, but the bright tones will be over-exposed. If you tap on the bright zone, you will usually get good exposure in the bright and middle zones, but

the dark areas may become blocked up. This leads me to the middle zone. When the middle zone is chosen for your exposure, you will usually get great midtones and good saturated colors throughout the image. However, you will see some compromise in the light and dark zones. With a good middle zone photo capture, you should be happy with the overall result.

Once you have the image file stored in your camera roll, you will be able to edit the photo to make it look better than the original capture. I suggest that you download a few image-editing apps to enhance and beautify your photos prior to sending them off to your favorite social media site or print house. There are several apps on the market that will allow you to finesse your exposures.

▲ *left*—You might decide that you want the brightest part of your image to be perfectly exposed. If so, tap on it, but be aware that this may mean that the rest of the image will appear too dark.

▲ *center*—You might decide that you want the midtone area of your image to be perfectly exposed. Tap on it and you'll likely find that you have a proper exposure—one in which the highlights and shadows show detail.

▲ *right*—If you click on the darkest area of the image to establish the shadows as the area that should be properly exposed, you may have some detail in the midtones, but the highlights will probably lose all detail.

Everyone's a Critic

More and more people are looking at photographers' websites and downloading information before ever thinking about making a purchase. Online, your products and services are being compared side-by-side to your competition's. Website-to-website and image-to-image, people make many of their hiring and buying decisions based solely on the way a website functions and looks.

The worst thing about this new reality is that you may never get the chance to speak with these people or point them to that specific area that makes you different. On average, it takes people just 10 to 15 seconds to engage with your website, brochures, or other two-dimensional content. If they don't like your images, they are gone in seconds!

▶ Introducing a prop helped make this model more comfortable. The fact that she's pulling on her dress adds a little tension in the image, which is engaging for viewers.

My experience tells me otherwise. Usually, you gather your subjects and they look uncomfortable. Then you notice they are all looking at you because you have the camera and they want you to tell them what to do. It's your photo.

The first thing to do is to take charge—confidently and nicely. 90 percent of posing people properly is having an idea of what you want to see. The other 10 percent is being able to communicate the idea to your subjects. After years of experience, I have found that once you have your subjects' attention they will do almost anything you ask them if you ask with confidence and purpose.

Here are some general guidelines for making your subjects look their best:

Get Your Subjects' Heads on Different Levels. This is probably the easiest way to dramatically improve your compositions for group photography. The idea is that by getting people's heads at all different heights, you will better fill the frame and create more appealing compositions.

One of the best ways to get the subjects' heads on different levels is to find a location that will naturally allow for it. For example, you could pose the family or group on a staircase so they are all sitting on different steps. This will easily break up any patterns of head levels so the group looks like one cohesive unit. You could do the same thing by placing the group on fallen logs or on boulders or any other uneven surface.

Make Sure No One Is Hidden. Even the best photos will be ruined if someone's face is covered. The flaw will be the first thing your client or family notices—even if the rest of the picture is perfect. I usually tell large groups of people, "If you can't see the camera, I can't see you." This might help for larger groups, but it makes people think that they are completely uncovered if their eyes can see the camera, so it's best for the photographer to take control and scan the group to ensure he or she has a complete view of each face before the shot is captured.

Let the Group Be Natural and Have Fun. Formal group photos are tough to pose because

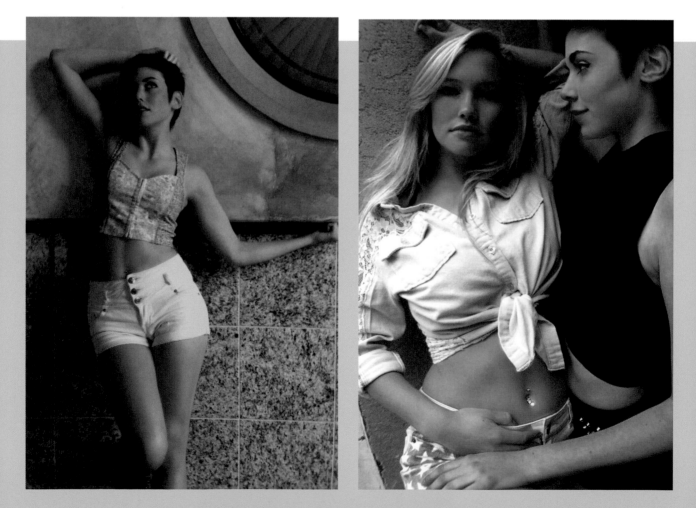

▲ *left*—Here the pose is a bit more forced but elegant. I had the model move through many poses to get this one.
▲ *right*—In an image of two subjects, each person should be posed in a flattering way and the two poses must work together.

people will not remain still. Even shifting their weight from one foot to another can completely change the pose. Posing a group of five or more can be like playing Whack-a-Mole. As soon as you get one in place, another one moves and you have to get the other one set! If the group is willing to try something different, you could completely throw the formal group photo out the window and just have fun. Here are a couple ideas for doing casual group photos: (1) have the group run toward the camera, or (2) have the group casually lounge on the couch and the floor like a family would sprawl out for movie night in the family room.

Take as Many Photos as You Can. Sometimes after a shoot, you sift through your photos only to find that in the "best" shot, one of the subjects wasn't looking at the camera. So frustrating! I usually take three or four photos at a time once everyone is posed and looking at the camera. It is more time consuming to do this and it can be a pain to edit additional photos, but it allows you to create composites and fix the photo in postproduction.

Check Your Lighting and Focus. Lighting groups can be tricky. There are basically two mistakes that most newbies make. First, they use only one light for a group. This will make people close to the light overly bright, while the people on the other side of the frame will be mostly untouched by the light. Second, photographers sometimes position the lights too close to the axis of the people, so one person's head throws a shadow on the next person. When photographing groups, I usually pull the lights in much closer to the camera than I typically do when shooting one or two people.

Tighten Up the Group. When you ask a group to pose, the subjects tend to stand too far apart.

Photographers sometimes position the lights too close to the axis of the people, so one person's head throws a shadow on the next person.

Having the group "squeeze in" so that the group takes up less space will allow for a more cohesive presentation.

Show Confidence and Take Control. If you shoot group photos for profit, you *must* take control. When there are a number of people getting together, things will be chaotic, and the shoot will take twice as long as it should if you don't step in to manage things. Your subjects won't know where to stand or what to do unless you tell them. These things don't pose themselves.

Keep It Simple. Group photos can quickly become awkward if you're not careful. Keep it simple.

Composition

Sure, there are times when rules can be broken for effect. However, most experts agree that using the compositional guidelines below will result in better images.

Simplicity. A simple composition can lead to a great photo. For simplicity, try including only a few elements in the frame. You can intrigue your audience with those simple elements through composition and exposure. Avoid cluttered backgrounds (change your shooting angle or move the subject to a less cluttered area). Get close and crop in-camera to ensure that distracting elements are eliminated from the frame.

Rule of Thirds. For more powerful, dynamic compositions, you can use a time-honored compositional guideline called the rule of thirds

to position the key elements of your image within the frame. To employ the compositional technique, imagine there is a tic-tac-toe grid superimposed over your image. (*Note:* In several camera apps, you can simply turn this grid on by choosing the grid icon.) With the grid in place, the image frame (or screen) will be divided into thirds horizontally and vertically. The rule of thirds dictates that your composition will be strengthened by placing the subject or an important portion of the subject on one of these lines. The points where the lines intersect are called power points. These points represent the ideal positions for subject placement.

By manually focusing on your subject, which will be placed at one of the prescribed positions, you can further strengthen your photograph and draw the eye predictably to the most important aspect of the image.

Consider this when composing your landscape images: All images are comprised of a

foreground, middle ground, and background. In some images, the delineation is not obvious (it is usually easier to see in landscape images than in some other genres). The rule of thirds divides the frame into thirds from top to bottom. For a well-composed landscape image, you can frame your shot so that the foreground falls in the lower third of the image, the middle-ground falls into the center of the shot, and the background is at the top of the frame.

Balance. Balancing the elements of a photograph through composition is very important. For example, if you are placing a large subject in the foreground, you might include an element with equal visual weight in the background to create a balanced feel.

Color is another element of the image that can be used to create a balanced feel. Photos that include primary colors tend to be dramatic. Warm, intense colors such as red, orange, and yellow should usually be used sparingly. It is best to limit these colors to a few simple elements in the photo as they draw the eye and create tension within the composition. The overuse of these high-energy colors, especially in contrast to each other, can overwhelm the viewer and can cause a type of visual anxiety. Try to balance these strong tones with calming neutral tones to create a sense of balance in the image.

Framing. Whether you are shooting with a DSLR or your iPhone camera, you'll need to effectively frame your shot. What this means, simply, is that you will need to determine what it is that you want to fit within the confines of your viewfinder/viewing screen. Framing the shot can be considered cropping in-camera. You can move closer to or farther from your main subject to change what will be seen in the final

◄ This image is simple in color and composition. It works because it is texture-rich and the rock in the upper left becomes a point of interest.

image and what will be excluded.

Of course, it is also possible to crop the photo in postproduction to refine the presentation of your shot.

Lines. Lines are present in every photographic composition. Sometimes they are obvious, and other times they are implied. Even a close-up of a face has certain compositional lines. Photographers use "leading" lines when creating powerful compositions. Leading lines draw the viewer's eye to the main subject. For example, a curving path that begins at the lower-left corner of the frame and extends to a pond in the top-right third of the frame will help establish the pond as the main subject—a visual resting place. Diagonal lines lend a dynamic feel, while horizontal lines are more restful. Repeating lines add compositional interest in the image.

▶ *top*—In this image, colors and textures are repeated throughout the frame, creating a sense of balance.
▶ *bottom*—I composed this image with the old carnival ride on the right side of the frame. This allowed me to leave negative space on the left side of the frame. The result is a pleasing visual tension in the image. The blue sky behind the ride shows through in several areas, providing a sense of balance.

◄ I composed this image to show the great distance these lines of gravestones covered. The converging lines draw your eye deep into the scene, while the horizontal lines help to depict the magnitude of the space.

▼ Here is the same plant photographed using three different camera angles. It's amazing how altering the angle of the shot can change everything.

Effective Camera Angles. Choosing the best camera angle for your subject or scene can require some trial and error. My advice is to photograph every angle you can imagine, keeping all of the photos until you have time to go through them. At that point, you can select the images you like best.

Avoid Common Problems

Low Light. Low light can destroy the photographic moment in seconds. Without enough light, you can't get a good shot. You might get lucky here and there and create a photo that looks cool, but my guess is that the "cool" photo you end up with will not be exactly what you had in mind when you set out to take the photo.

When you are out at a restaurant, at home in the evening, or outdoors at night, you may need to activate your iPhone's LED flash, turn on a light, or both. You may also tap the screen on the part of the photo that you want to be brighter. You may lose the background detail, but you will get the photo.

Poor Light. Poor light is different from low light; it isn't insufficiently intense, it is just plain ugly light. This issue can sometimes be resolved by repositioning your subject. You can also try to shoot from a different angle or viewpoint. One of the benefits of shooting with an iPhone

camera is that you can look at the screen and judge the light on your subject prior to snapping the picture.

For the best results, try to avoid deep shadows on a face from overhead sun or multiple shadows from several light sources. Most of the time, that kind of lighting is just plain ugly.

Bright Backgrounds. Many iPhone photographers capture images with the sun directly behind or to the side of their subject. Remember, the camera bases the exposure on the brightest area of the shot. If the light behind the subject is brighter than the subject, the subject will be too dark.

In iOS 7, you can split the focus-point selector and the exposure-adjustment selector. Simply "unpinch" the focusing circle (with your fingers pinched together, make a reverse pinching motion on the screen). This will create two circular icons—one to choose the focal point and the second to choose the exposure area. You can then tap on the darker (subject) area of the image and expose for that area of the shot. Of course, this means that the brighter area of the shot will likely wind up blown out (i.e., it will be rendered white, without detail).

In iOS 8, tap on the screen where you want the main focus to be. Once you've established the focus point, softly touch the screen. You will see a yellow sun icon on a yellow vertical line next to the focus square. Scroll your finger up and down and watch the exposure change on the screen. This is a great way to choose the perfect exposure.

Blurry Images. Blurry photos are bad photos. There are several things you can do to improve your odds of getting a sharp image. In iOS 6, simply press and hold the camera icon until the camera achieves focus, then snap the photo. In iOS 7 and 8, touch the screen where you want the focus to be and the camera will make the required adjustments. A great trick to keep moving subjects in focus is to pan (move the camera to track the subject's movement) and hold down the "take photo" button. (*Note:* In iOS 8, holding down the "take photo" button will activate the burst mode.)

Other steps you can take to prevent blur include adding light to the scene so that the camera will choose and use a shutter speed that is fast enough for a hand-held exposure or mounting the camera securely on a tripod.

Red-Eye. Although red-eye is easily removed with software within your iPhone it is still important to understand how to prevent it. The easiest way to prevent red-eye is to not have the camera lens directly level with the eyes of the people you are photographing. Most times red-eye is caused by the camera's flash (or, in our case, the iPhone's LED flash) hitting the inside of the eye and reflecting back into the camera. Red eye is usually not a problem when using your iPhone. However, if you see red-eye when you view your image on the screen, move the camera a little in any direction so the flash will not fire directly into the pupil.

Flash Exposure Is Too Bright. There are two scenarios in which it is likely that your flash will be too bright in your image. The first scenario is when you are too close to your subject

Try to avoid deep shadows on a face from overhead sun or multiple shadows from several light sources. Most of the time, that kind of lighting is just plain ugly.

and shooting in a dark environment. If you are shooting indoors, adding light can remedy this problem. Consider turning on extra lights in the room. If you are shooting outdoors at night, you will probably just need to back up a little. Look through your viewing screen and back up a few steps until you get the correct exposure. Remember to touch the area of the screen that contains the tones that you want to expose for.

Poor Cropping. Cropping is the final step in ensuring a good composition. Often when you are shooting, you are thinking fast. It's best to err on the side of caution and include more of the scene than you need when capturing an image. You can easily crop a subject's foot out of a shot using iPhoto, TaDaa, Darkroom, or other apps. However, adding a missing foot is not usually possible, no matter which apps you have.

The rule of thirds is an important tool for ensuring a dynamic composition. It also applies when cropping. Lean on the rule of thirds to aid you in making great compositions from the photos that you intend to crop.

◄ The converging white lines in this image draw the viewer's eyes through the image.

6. Artistic Effects

There is no shortage of incredible apps on the market that can be used to personalize your work. The apps that follow are a good starting point for investigating your options.

 ### EyeEm
EyeEm is an incredible app for capturing images and adding effects. There is even an amazing online portal that allows users to connect with other photographers and even upload and sell images in the international market. This is a must-have app! Image 1 was taken using EyeEm.

 ### Hipstamatic
I use Hipstamatic all the time. I love the very original images it produces. The app offers a selection of great borders, plus fabulous color and contrast options. The downside? I wish I was able to import a photo previously taken.

 ### ShakeitPhoto
What makes this camera app great is its lack of options; it's point & shoot at its best. When I need a great-looking photo fast, I use this app. Another nice

thing is that you can shoot an image with the app, and it also saves an original version of that image in your library.

 ### TiltShift Generator
When I don't want to drag my 4x5 camera around, I'll use this app to produce a similar selective-focus effect. The interface on this app is a pleasure to use. For a

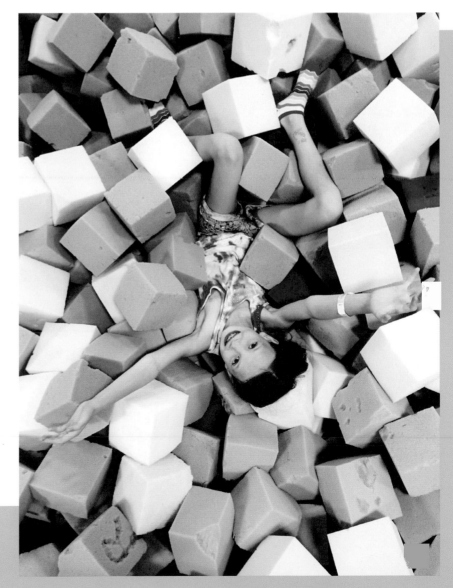

▶ Image 1.

look at a sample photo created with this app, see image 2.

lo-mob
This app offers thirty-nine vintage and experimental filters. I love the selection of retro film borders that are available in this app. The newest version lets you turn on borders and effects. You can even add a border to a photo processed in another program. See image 3.

True HDR
HDR is always fun to play with. True HDR does a great job aligning the photos and keeping the detail.

99 Fonts
This app allows you to add type to your photos. The interface is nice and simple to use. It has standard presets like Lomo and some unique ones like multi-exposures.

Fisheye
Fisheye is a great little app. Add this one to your app arsenal and have some fun. Image 4 shows a sample of the effect.

Filterstorm
Do you like having total control over the colors that affect the look and feel of your final image? If so, this app is like filter heaven. It will allow you to create amazing color variations, tints, tones, and more.

▼ Image 2.

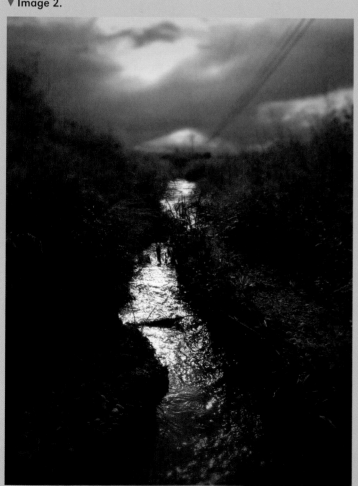

▼ Image 3.

SwankoLab

This app is made by the creators of Hipstamatic. There are endless possibilities for effects, which is why I'm glad you can import a photo. I take a photo with the iPhone camera app, then bring my pick into SwankoLab for processing. I can try out different effects on the same photo until I find one I like (that's not possible in Hipstamatic).

CameraBag 2

This simple and straight-forward app produces nice results. The manufacturer also offers a desktop app for the Mac, which is fun to use. Image 5 was captured with this app.

QuadCamera

When just one photo won't tell the story, I use this app. The downside is even when the capture rate is set to slow, it's a little too fast for me. I need more time to think about the next photo.

TRYPTpic

This app offers eight standard cropping sizes and a smoothing algorithm for noise reduction.

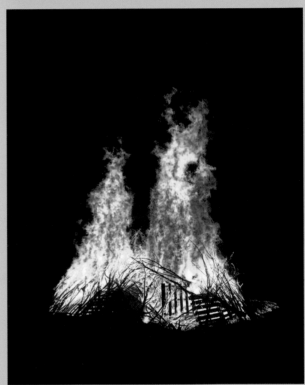

TaDaa

TaDaa is a powerful HD iPhone-only editor. It features more than one hundred live view filters and more than a dozen editing tools. See image 6.

7.0 MPX

This app offers a 7 megapixel resolution, zoom, and many other features. It's great for night photography.

▲ *top*—Image 4.
▲ *center*—Image 5.
▲ *bottom*—Image 6.

Night Modes

Night Modes allows you to add up to one second to your shutter speed, permitting you to capture brighter, low-noise images at night. See images 7 and 8.

LongExpo Pro

This app offers high native resolution images. You can capture motion blur and light trails and can also add artistic effects after capture.

Wow FX

This low-cost app can be used to add realistic nature, space, magical, or light effects to your photographs. It also offers an array of filter effects. See image 9.

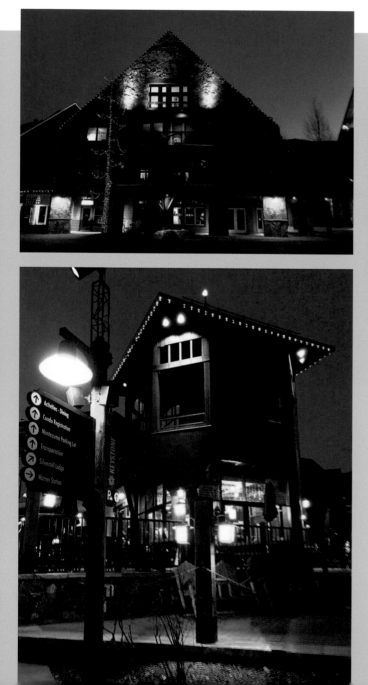

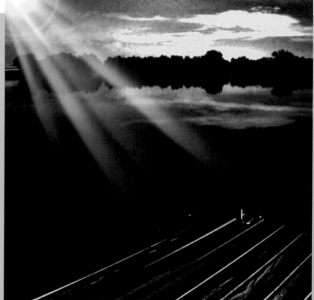

◄ *top*—Image 7.
◄ *bottom*—Image 8.
▲ Image 9. This shot was made on my iPhone 3 using iOS 6. The dock, water, trees, and sky were all part of the original image. The bright sunlight rays were added using the WowFX app.

7. Workflow

A Watertight Workflow

To get the most out of your iPhone photos, you'll need a good workflow. For professional photographers, having a watertight workflow is absolutely critical: it ensures efficiency, quality, and image security.

Think about this: You take photos, want to edit photos, and plan to share and maybe even print your photos. This is all good and fine until you end up filling your device's memory and can't take any more images. To capture your next great photograph, you'll need to quickly delete shots to free some space. Once you take a few more photos, you run out of memory again. Ugh!

An effective workflow for the iPhone allows you to take photos, store the files outside of the camera, access the shots quickly for editing, and store them once they are processed. I suggest you find a cloud-based storage system that allows for upload via your phone. I have chosen Dropbox, and I pay $9.99 per month for 100 gigabytes of storage.

Here's how it works. I take photos using my iPhone. Every time my device is connected to Wi-Fi it uploads my photos to Dropbox! Stored. I download those photos to my computer for editing and sorting. Once I have culled and edited my images, I upload them again to Dropbox, where they are safe and always accessible. Easy. I am now able to delete photos from my camera roll at any time without worrying about losing them.

Here's the rundown of my workflow process, step by step:

1. First, I identify the subject I will photograph.
2. I unlock my iPhone and open the default camera app.
3. Next, I frame my shot, look at the image on the screen, and analyze the lighting.
4. I then touch each of the three exposure zones (highlight, midtone, and shadow) and

▲ Old workflow.

▲ New workflow.

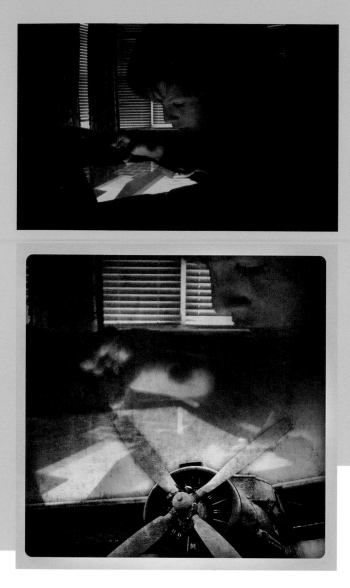

◄ *top*—This is the original image from the iPhone using the iOS 6 camera and no filters.
◄ *bottom*—Here is the same image, cropped and stylized using the FilterMania 2 app. What a difference!
▲ Here, a photo of a clock was taken to a new level of awesome using filters available in the FilterMania 2 app.

watch how the light and exposure changes in the image on my screen.

5. After I find the exposure zone I like, I open the filters and choose one that enhances the photo. (Once a filter is selected, its effect is visible on-screen.)

6. I run though the exposure zones again, as applying a filter can affect the exposure.

7. At this point, I take multiple photos (both vertical and horizontal) from several camera angles, creating various compositions.

8. Once I think I have the shot, I open my camera roll and check to make sure my images are in focus. If they are not in focus, I take the photos again.

9. Next, I open the EyeEm app and choose my favorite photo from the series of images. After I have imported my favorite shot, I swipe to browse the filters until I find one that I like. (*Note:* As mentioned above, I use an iPhone camera filter on my original image. When I open the shot in EyeEm, I apply a second filter. This means that two filters are applied to the photo.)

10. I hit Save, and the processed photo is stored to my camera roll. I am then free to take another photo.

11. When I arrive at home and my iPhone picks up the Wi-Fi, my photos are uploaded to Dropbox. I then import them into my computer and do detail work in Photoshop. I typically change the resolution to 300dpi and choose 11 inches for the longest dimension of the photo, save the file, and print/share it.

Storing and Sharing Your Images

There are countless apps that you can turn to when it comes to backing up your files and sharing your images with clients, family, and friends. Here are some of the apps I have tested to ensure they work.

Dropbox and iCloud. Dropbox is an online Cloud storage program. Download the app and you can upload your images to the Cloud for safekeeping. iCloud is a Mac-based Cloud storage system. You can access your files via any of your Mac devices.

Facebook, Pinterest, Instagram, Blogger, Tumblr, and Flickr. These social media sites make it easy to share your images with other subscribers. Each site has its own focus and forte. Check out their apps.

Photobucket, Shutterfly, Picassa, and Snapfish. Download apps from these companies and you'll have the ability to share, store, and print your images from your iPhone!

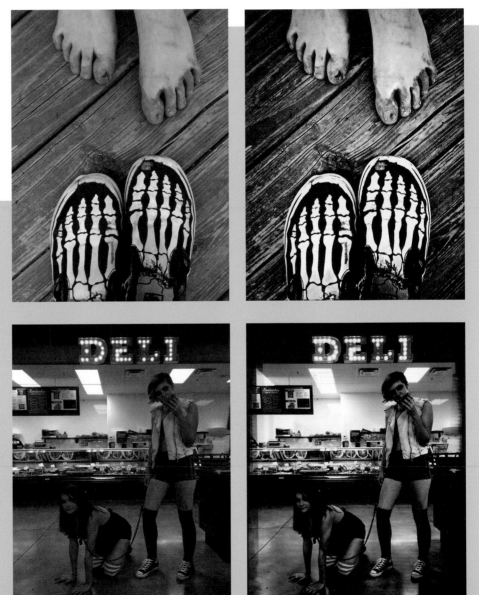

► *left*—Original image.
► *right*—This image shows the impact of using an image-editing app and a fun filter from the EyeEm app.

► This shot is another example of how a few good apps can turn a "normal" shot into something cool and unique. With experience, I have learned to anticipate the effect of filters that I repeatedly use. I took this shot (left) knowing that using filters from EyeEm and FilterMania 2 would allow me to create the "heroin chic" look I was after (right).

8. Postproduction Apps

As you're well aware by now, your camera's iOS offers you the option to apply colored filter effects after you capture your image. But why stop there? There is no shortage of incredible apps available for download in the App Store. They all do amazing things. As a professional photographer and educator, I have only included discussions of apps that allow for a high-quality, flexible image output. There are several apps out there that do not offer you a better experience as a photographer. These apps can degrade or destroy your original image file. Please read reviews on any app you are considering using before you employ them.

Instagram

Instagram is a wildly popular app. Image 1 shows the screen from which you can add color-enhancing filters to your existing photos. The image shown is "normal." You can also enhance contrast, add a frame, or blur the image edges in Instagram.

Image 2 shows a view of the screen that allows you to add edge-blur-enhancing filters to your existing photos. This is a particularly effective effect when photographing food.

EyeEm

EyeEm offers a fantastic number of options for editing your image after it has been captured. EyeEm allows you to add color-enhancing filters and simple or artistic frames to your photos. EyeEm is my hands-down favorite app for this type of work.

iPhoto

iPhoto is a great go-to app for editing your images. Image 3 shows the main screen, where you can import photos or look at stored image files that you are working on. Image 4 shows some of the tools available for enhancing your images.

iPhoto is a one-stop shop for organizing, editing, and sharing your favorite pictures on

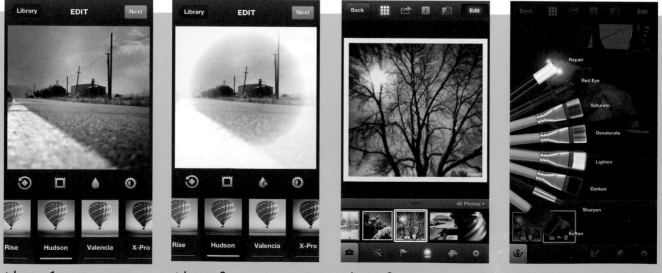

▲ Image 1.　　▲ Image 2.　　▲ Image 3.　　▲ Image 4.

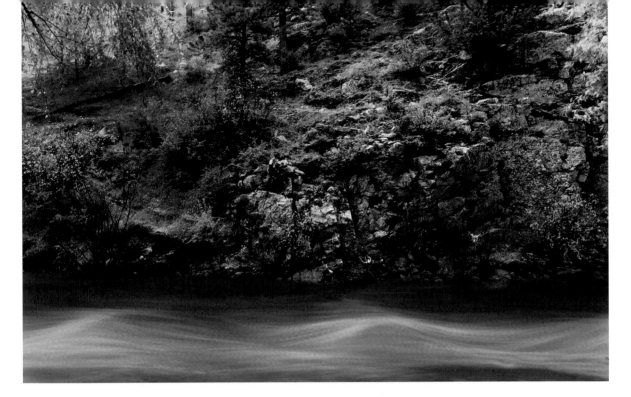

▲ This image was taken using the Long Expo Pro app. I then altered the image colors using the iOS 7 camera app. Creating an image like this is easier with an iPhone than it would be using a DSLR.

your Mac or PC. In addition to touching up an image or changing its size, with iPhoto you can create a slide show of multiple images, design custom cards, e-mail your photos from within the program, or post them on Facebook.

To use the app, follow these simple steps:

1. Connect your iPhone to your computer using the USB cord that came with your iPhone.
2. Wait for iPhoto to open. If the program does not open automatically, open it manually. (This may be the case, depending on your settings.) When iPhoto is running and the iPhone is connected, it may take a few minutes for the iPhone to appear in the iPhoto sidebar.
3. Click on the name of your iPhone under Devices in iPhoto. By default, the iPhoto program will have divided the imported

images into different "events" based on the dates the photos were taken. If you do not want your photos sorted in this way, uncheck the Split Events box just under the images.
4. Hide any photos on your iPhone that have already been imported into iPhoto by checking the Hide Photos Already Imported box at the bottom of the iPhoto screen.
5. Import all of the images in the display screen by clicking the import all icon located above the images. If you only want to import certain pictures into iPhoto, hold down the Command key while using your mouse to click on the images to be imported. Click Import Selected, which is also located above the pictures.
6. Wait until all photos are imported before you disconnect the iPhone from your computer.

9. Real-World iPhoneography

Food Photography

Photographing food is easier than you might think once you get the hang of it. Using the telephoto lens from the iPro Lens system made getting these shots simple. When you are taking food photos to show other people (e.g., posting your images on Facebook, Pinterest, or Twitter) you want the food to look delicious and inviting. You especially want the food to look good if you are writing a review for your favorite restaurant or are showing off a family recipe.

I have been professionally photographing food for over twenty years, and I can tell you that there are a few things that are needed in the good-food-photo formula. First, you need believable color. A blue burger is not appealing, so don't go crazy with filters when you are taking and finalizing your shots. Second, you want the food to be in sharp focus and the area behind the food should be blurry. This is usually achieved in one of two ways. Because the iPhone camera lens in basically an infinite focus lens, it can be difficult to fully control the depth of field. For added control, you can use an app like TiltShift Generator. Alternatively, you can use a telephoto lens from iPro for a narrow depth of field that will make your food photography look its best.

For the best-possible food shots, don't take bites out of the food, salt it, take the shot from far away, or use a black & white filter mode.

The iPhone camera (with proper lenses, light, technique, and a bit of style) takes amazing food shots at record speed. I was on assignment for a local magazine to shoot delicious recipe images. I went to several busy restaurants and had to work during their operating hours. I wanted to use as little equipment as possible, so I brought my tripod, iPhone, bounce cards, Schneider lens kit, and a few Rotolights. Everything fit in one case.

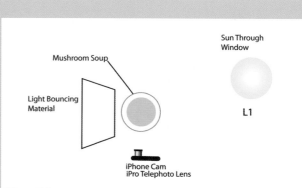

▲ Here you can see the position of the soup, the camera, and the bounce card. This is a great example of using window light and a simple bounce card.
◀ This shot was made with the Schneider telephoto lens.

▲ ▼ When it comes to food photography, a lot depends on the characteristics of the food you are photographing and the light that you are presented with. For the best results, use a telephoto lens and a narrow depth of field or get as close as you can to the food with your iPhone's camera lens.

To get the soup photo (page 62), I chose to use a table that was long so I could get the shallow depth of field seen in the shot. The table was next to the front windows of the restaurant, so it was basking in beautiful available light.

The light coming through the window was a little softer than normal sunlight due to an awning outside the window. It looked like the light on a bright, cloudy day. By placing a bounce card on the left side of the soup bowl, I was able to equalize most of the exposure.

Drinks

Let's take a look at a few simple tips and techniques that will help you get great photos of your favorite drinks. First, let's remember that drinks come in all colors. Some of these drinks, when in a glass, are a darker color than you might expect. For example, red wine in a glass appears very dark in certain light. When you have dark liquid in a glass, the glass becomes highly reflective and mirror-like. This can usually be resolved by adding bright overhead light, bright directional light, or both.

Second, we must consider the surface that the drink will be photographed on. Is it a polished, reflective surface? A dark wood surface?

A simple white surface? A simple tip is to control your camera angle to ensure that the surface the drink is on isn't reflecting into the glass.

Finally, take a good look at the light you are in. Are you in a dark room, and will the drink be photographed against a dark background? Are you in a room with bright lighting, and will the drink be photographed against a light background? Are you in a scenario that has bright light and a dark background or dim lighting and a bright background? You will achieve the best results when the tonal range in your images is reasonably compressed. Remember, you want detail in the highlights and shadows. For the best results, therefore, look for a background with interesting light or reflections—but try to ensure that the background and foreground are similar in tone.

Once you have examined all of these variables, you are ready to take your photos. It sounds like a lot to consider, but once you get used to thinking like a photographer, it all comes to you in a few seconds. Remember to take several photos of the drink. You can always delete any images you aren't happy with from your iPhone's camera roll.

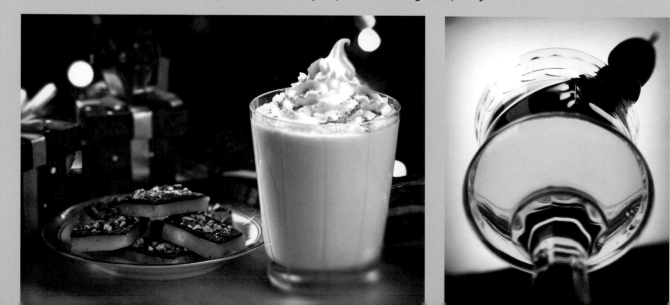

▼ You can add lots of props and create a shot that is a balance of great technique and styling or take advantage of an interesting camera angle and let the qualities of the subject (here, its striking color) carry the shot.

▶ *top*—Using filters from the EyeEm app allowed me to send this photo back in time. This is a modern twist to an older genre of the heroin chic photography style.

▶ *center*—This photo was taken by someone we didn't know. I have noticed that photos like these are always better on an iPhone than when I hand over a big DSLR.

▶ *bottom*—One of the coolest things about the iPhone camera is that you can turn it to look at yourself—or your whole family. It's fun and great for recording memories.

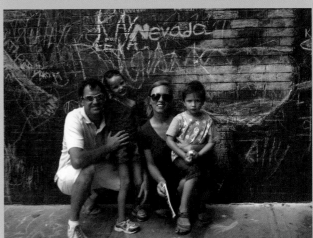

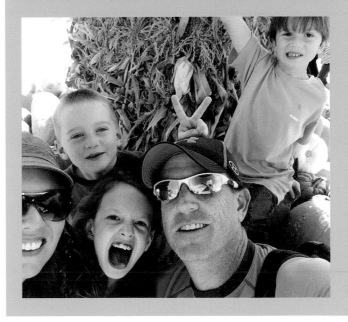

Editorial/Journalistic Photos

Editorial or journalistic images tell a story. To create images that stand out, you must be able to use available light to make them interesting. In this book, I have detailed the types of light that most photographers will encounter while taking photos. Editorial photography is the perfect place to test your skills and learn. When you are taking photos in editorial style, think of the story you see, then judge the light. Make sure that you take as many photos as possible when you find something that interests you.

What I find most interesting about taking editorial type photos with the iPhone is that the people I'm photographing don't know I am taking photos of them unless I tell them. In comparison to a DSLR, the iPhone seems to just blend into the landscape. Everyone has a phone these days, so no one really pays attention when you pull your phone out. If you are able to do some clever hand-holding of your phone, you can take photos of real-life situations as they unfold, without anyone knowing.

Family Photos

Most of us take a lot of family photos with our iPhones—and they may be the most cherished photographs you will take. People typically have

a phone with them at all times these days, so we have plenty of opportunities to document special moments as they unfold.

Here are some tips for making the best-possible family portraits:

1. Study the light where you are.
2. Check to see if the light is sufficiently diffused and soft and identify the direction that the light is coming from. If the light is poor, move yourself and your subject to another location.
3. Pose everyone if needed.
4. Focus the iPhone camera, tap a subject's face to expose for the skin tones, and take the shot.
5. Say something funny, then take another shot, and then another. You can always throw away images that you don't want to keep, but if you get just one shot and hate it, you're stuck.
6. Back up your family photos regularly. Never risk losing your precious memories. I personally use Dropbox to back up all of my photographs.

Pets and Wildlife

Taking photos of your pets is similar to taking photos of family and friends. It's even more like photographing children, except in most cases you will be pointing your iPhone camera toward the ground or aiming into strange corners where your pet may be doing the cutest thing ever. Outdoors, you might find that you're trying to photograph something that is almost always farther away than you expected. Like kids, animals rarely stand still—and you won't be able to get them to re-enact a movement or expression if you didn't get the shot right the

first time—so take lots of frames to increase the odds that you'll get a keeper.

When you're trying to capture fleeting moments, it's important to note that the photo is only taken once you take your finger off of the "take photo" button. That's right, in iOS 7, you can focus your shot by holding down the camera icon on the screen. While you are holding the camera button, you get a real view of what the photo should look like before you take the shot. This action will also force the camera to expose the scene for the light in that focused area. If you like what you see on the iPhone camera screen, then remove your finger from the button and take the photo. In iOS 8, you simply place your finger on the screen in the area of the image that you want to be in focus. You can also move your finger up and down to scroll and change the exposure, reducing or increasing the overall brightness as needed.

To take photos of a moving animal, first focus on the subject, then track the moving animal with your camera. For example, if you are photographing your dog running in the park, you should move your camera, while focusing, along with the motion of your dog. This does not mean running alongside your dog. This means panning your camera in line with your dog's stride. Once the camera is focused and your dog is in the middle of the frame, if possible, remove your finger from the "take picture" button and take the shot. This will give you a cool looking photograph of your dog in focus, with a blurry background.

Let's say we want to take a photo of fish in an aquarium. The number one thing we have to deal with here is getting the shot through the glass. Thank goodness we can manually turn off the flash on the iPhone because you

can't get good photos through glass with your iPhone's LED flash. Manually turn your flash off by touching the flash icon, then selecting Off. Next, focus the camera and check the lighting in the shot. You may need to move around a little to make sure you are not getting reflections from windows or room lights on the glass. If the room lights are on, turn them off if possible. The lights in the aquarium should provide enough illumination for you to get a great photo.

I recommend that you run these images through the Darkroom app. Using this app will allow you to easily control the vibrance of the colors in the scene.

▲ *top*—This shot was taken with the Schneider telephoto lens. I held the phone in the horizontal position and used the grid feature while composing to make sure that the landscape was straight. I brought the original photo into Photoshop and increased the vibrance.

▲ *bottom left*—My pug. Most pet photos are taken from a standing position. Remember to say the pet's name when taking the shot. This way, you will get a great expression. I added a filter in Instagram to make the shot a little more interesting.

▲ *bottom right*—This is a perfect cloudy day photo. The seagull decided not to move at all, making my job easy. I set my exposure by tapping on the midtone area of the image.

▲ *top*—This is an example of an interesting long exposure. The exposure was half a second; this caused many of the people in the photograph to blur. I then used EyeEm to add an interesting filter and color accent to the shot.

▲ *above*—I used my iPhone 6+ and the panorama option in iOS 8 to capture this great shot showing one of my crew members conducting an interview in this large arena.

Interiors

Interior photos deserve a little panache. This means you need to get the table surfaces clean and remove trash cans and other ugly items from the view of the camera. You will also need to be a lot more conscientious when it comes to the lighting. The iPhone camera does a pretty good job of handling mixed-lighting scenarios (i.e., a scenario that may contain window light, incandescent lighting, and fluorescent bulbs in combination; it's a commonplace scenario in interior spaces.) My DSLR? Not so much.

When shooting interiors, you want to immobilize the camera so that the objects in your final shot will have crisp, tight edges. The best thing about locking your camera down on a tripod is that you are forced to think about the shot before taking it. Think like a photographer. This is often the line between good and great photos.

◀ The repetition of the chairs, name, and circles in this image lend a sense of panache. The warmth of the light also contributed to its success.
▼ This shot was simple to create with my iPhone camera. I was able to capture a beautiful exposure of a scene lit with a variety of lights, then run an EyeEm filter to enhance the color. A DSLR just isn't up to this task.

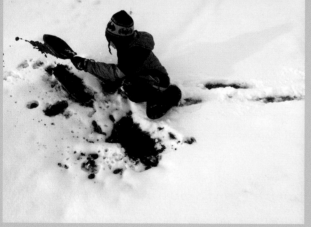

▲ *top*—When I captured this image, it didn't appear cold enough. I opened the image in EyeEm and applied a filter that increased the contrast and cooled the whites. It definitely looks cold out there.

▲ *above*—I wanted this image to show the resilience of people in snowy weather. I used the Dark Room app to render the image in black & white. The negative space on the left side of the frame helped to show how much snow was around and created a more interesting composition.

Snow

The main issue you run into with taking photos in the snow is the whiteness of the snow itself. The sun reflects off of the snow, and the camera's internal meter reads the scene as being extremely bright. This causes the camera to choose between exposing for the bright snow or the darker subject. This is the perfect time to use a light meter app. Doing so will allow you to get an accurate exposure. You might also consider using the 645 Pro MK III app for complete manual control over the exposure.

Now, imagine you are photographing a person wearing a dark jacket in the midst of all of that snow. This scenario is trickier for the camera. If the exposure is calculated to preserve detail in the snow, any detail in the dark jacket may become blocked up and lost. What do you do?

If the subject, not the snow, is the focal point of your image, you will get better results if you frame your subject tightly, eliminating as much of the snowy area as possible from the frame. Doing so will help your camera expose for your subject.

A second and simpler way to get a decent exposure for your subject is to tap on the subject. This approach is great in a pinch. However, you may find that you lose some of the detail in the bright area (here, the snow). This is the perfect situation in which to try the middle exposure zone. Simply tap the brightest part of the image, then the darkest area, and finally the middle tone. You can determine which exposure works the best for your scene. In iOS 8, you can scroll up and down using your finger to control and select the best exposure.

Action Photos

The newer your iPhone, the better your camera will be at capturing action photos. Newer models have bigger chips and file sizes and, more importantly in terms of the discussion at hand, they offer a much higher frames-per-second capture rate. This means that it is easier than ever to freeze and capture motion.

To increase the odds of getting action photographs that are sharp, pan with the action and focus. Be aware too that half of the battle of capturing action is anticipating where the subject *will* be.

With iOS 8, your phone offers a continuous shooting (burst) mode. Simply press and hold the take-photo button; your camera will capture a rapid sequence of shots until you let go of the button. With this feature activated, you really can't miss the shot.

QR Codes

QR codes are seen everywhere these days. They are typically used to disseminate information (often from product manufacturers). You simply download a barcode reading app, scan the QR code with your iPhone, and proceed to download a mobile app, view a video, respond to a questionnaire, etc. The code's creator can track information about the number of times a code was scanned, the action taken, and compile data about the device used to scan the code.

To ensure that your barcode-reading app will be able to deliver the information you are after, you will need to get a good, clean shot of the QR code. First, get your camera as close as possible to the pattern so you can fill as much of the viewing screen as possible. Position yourself to ensure there are no shadows falling over the code. Do not cut off any part of the QR code's pattern. Focus, hold the iPhone level, and take the shot.

▲ *top*—Using the continuous shot mode in iOS 7, I was able to capture my son Gavin in midair, jumping onto an invisible dragon.

▲ *above*—This photo of my daughter Renya was taken a while back with an iPhone 3. To get the focus in this shot, I had to anticipate the movement of the ride and track it. I called out her name, she looked over at me, and I basically got lucky!

▶ Remember to get the QR code in the middle of the camera's viewing area.

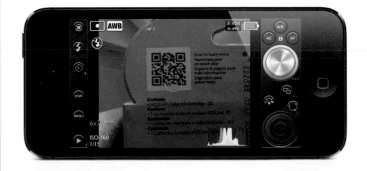

Concerts and Public Events

Concerts and events are chock full of changing lighting patterns and fast-paced motion. Often, these photographic challenges are compounded by the fact you have people all around you. If you are far from the action, you might feel that getting a great shot without a telephoto lens will be next to impossible.

These events are cool, and I have some tips for creating well-executed shots.

The first rule is to get out of your seat and get as close to the stage or action as possible.

◄ I made sure to arrive at the show early so I could get to know everyone in charge. They gave me access to the stage so I could shoot from these awesome angles. I like that the upper-right corner is filled with bright light.

◄ Shooting from a low angle can add a dramatic feeling to the scene.

► I just happened to be in the right place at the right time to capture this photo. I did not capture this dancer in motion. He actually stopped like this in mid-dance. I was fortunate to have my iPhone out and my camera focused.

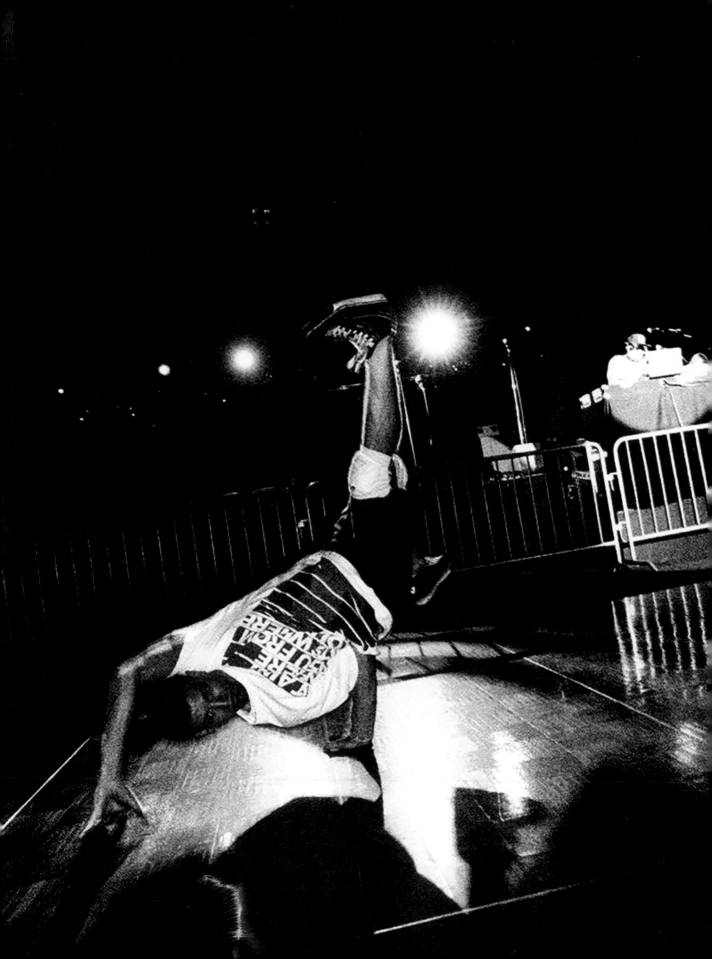

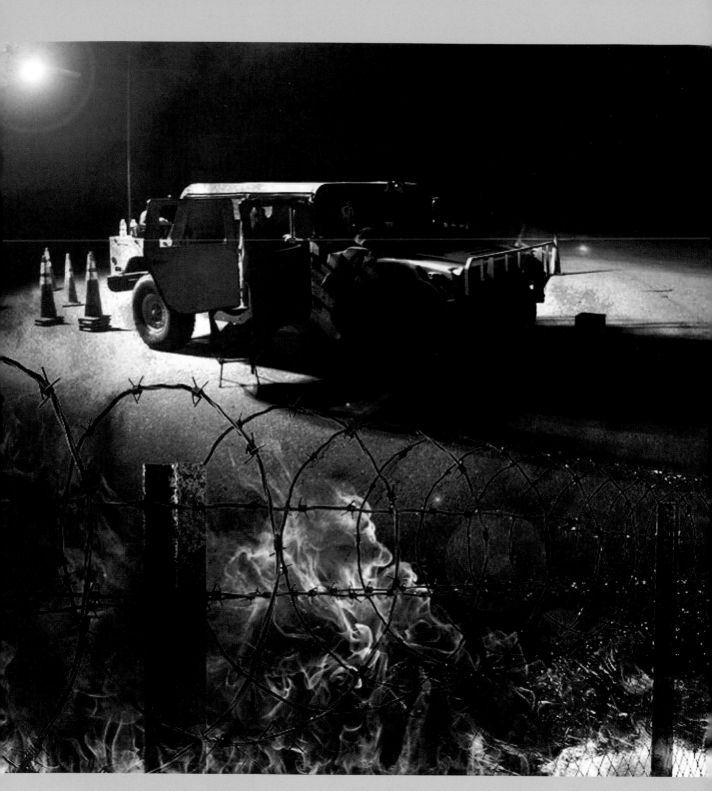

▲ I normally put the iPhone on a tripod when taking a night or low-light photo, but in this case I was able to capture the shot while standing very still. I did use the iPhone camera's flash to add a little light on the National Guard Humvee. I wanted this image to be extreme, so I opened it in the FilterMania 2 app and applied one of the War filters, then I brought the image into the app Dark Room and started playing with the vibrance and saturation. This made all of the colors pop and made the scene appear more realistic. To make the photo larger in size, I used the Big Photo app. Finally, I opened the image in Photoshop and used the Clone tool to remove the other vehicles and add lens flare where the image was already bright. The editing took about 3 minutes.

Your ticket to the event ensures that your seat will be reserved for you. The closer you are to the action, the better the photos you will capture. If you can sneak up to the stage for a few shots, you will be glad you did.

Choose your exposure wisely. In most stage-lit scenarios, you should expose for the brightest area on the stage. That area could be a person's face or the glimmer off a drum set or even a special light on stage.

When people are moving on stage, track them with the camera. This way, you have a better chance of "freezing" them.

Don't be afraid to hold your camera over your head to get better access to the subject. Take the photo with the camera up high, then check that you've got what you are looking for. I think it's rude to capture videos this way, but it is socially acceptable to take a photo like this in a crowd.

Using a telephoto lens with your iPhone will allow you to get closer shots from farther away. Using an app that allows for faster exposures will allow you to capture crisper images of moving people.

Photographing Photos and Documents

Photographing a photo or document can be easily done if you follow a few simple tips. First, tape the photograph or document to a wall that is near a window. Do not allow the sun to shine directly on the print or document; you want uniform lighting like the light you would find on an overcast day. Hold your camera straight up and down so that it is parallel to the document, drawing, or photograph, then focus and ensure your exposure is correct. Hold very still and take the photo. Voilà!

Night Photography

Night photography can be extremely challenging. Though the iPhone makes it easier and quicker to get the right exposure in dark environments, it is extremely sensitive to light, so you may end up with light traces in long exposures. You may also capture blurry images due to camera shake if your iPhone is not stabilized.

The main issue when taking night photos is that you do not have enough light to create a hand-held exposure. To create an effective image, you'll need to download an app that allows you to take longer exposures (Night Modes is a great option) and you will need a tripod or stand to hold the camera steady while you get the shot. Keep in mind that the iPhone will need to be stable enough on the stand that when you push the take-photo button, you do not move or shake the iPhone. Any camera movement will cause blur in the final shot.

You will almost certainly see a starburst effect from any light source, which can look interesting.

Most night-time and long-exposure apps will allow you to choose and use a variety of shutter speeds. Do yourself a favor and give it a go; doing so will change the appearance of the scene, and you can then select your favorite shot.

Most night-time and long-exposure apps will allow you to choose and use a variety of shutter speeds. Do yourself a favor and give it a go; doing so will change the appearance of the scene, and you can then select your favorite shot.

▲ This photograph shows just how much control you can have with your iPhone camera and a few LEDs. The set was no more than 3x4 feet, and I didn't really use any special techniques to get the shot. I merely aimed the lights at the statue, then used foam-like material and bounce cards to block or reflect the light as needed. I did curve the background so that I could control the depth of the scene. A curved background gives the impression of an infinite background if done properly. This way, you can worry about getting the entire product in focus and not have to worry about what the background looks like or how to light it.

Online Auctions and Personal Stores

When shooting photos of products for any reason with your iPhone camera, it is important to start off the process with a clean and open table space. To pull off the shots in this section, you will need some small mirrors, LED lights, and a malleable material that you can use as a background.

A Clean Background. The first thing you're going to need is a white, gray, or black background. (Try foam core; it's inexpensive and malleable and readily available at most craft or hobby stores.) You'll notice that the majority of products are shot against white backgrounds; they simplify the shot, allowing you to focus on the product. Shooting against a white background also means the product is easier to "clip out" in Photoshop if need be.

Lights. You will typically want the product to be evenly lit, with no harsh shadows, so be sure to set up in a room with bright lights or sufficient window light. You can use many types of lights to fill in shadow areas (e.g., flashlights, small LEDs, or a regular bulb); just remember that the iPhone's camera is extremely sensitive to light. You may want to find the middle exposure area or simply adjust the exposure to make it a little lighter than normal.

Framing. Simple compositions tend to work best, so try to get on the same level as your product and zoom in as much as possible. Avoid shooting from strange angles. For example, if shooting clothes, then shoot from straight-on to the item so that there's no distortion due to perspective.

Product Position. In product photography, you don't want your background to be in focus, so place the product a bit in front of the background, then use an app like 645 PRO MK III

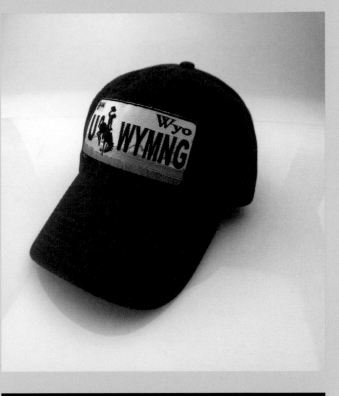

▲ *top and above*—These images show the effort that must be taken to get a good product shot. I placed a light to the left and a large light above the product. My iPhone was inside of the mCam's housing and was held in place by an articulate arm clamped to the product table. You can see that I used small cosmetic mirrors and a piece of white foam core to bounce light back onto the hat.

▶ *top right*—This is the perfect product shot of this hat. There is a clean background, and you can see all of the important details of the hat. This was shot using the iOS 8 camera, with no filters added and no postproduction work in Photoshop.

▶ *bottom right*—This shot was definitely complicated, and it's worthy of inclusion in a portfolio. I used LED lights to light one area of the product at a time. Once an area was lit, I took a photo. Each photo was a piece of the lighting puzzle. I then took each exposure into Photoshop and overlapped them. I blended each exposure by erasing the layers, allowing only the dramatically lit areas to show through. *(Note:* I used a tripod to capture the images used to create this composite.)

◄▲ These photographs were made with a macro lens attached to my iPhone.

to choose a wide aperture. You want the product in sharp focus, with a white, out-of-focus background. You may have to experiment a bit to get it right.

Make It Your Own. When you're done with all the technicalities, it's time to put your own stamp on the images you take. Play around with product placement and focus, and take as many images as you think is necessary. It's better to capture a range of shots and choose the one you want than to miss the shot and have to re-

shoot. Make sure that the resulting image tells the story of the product. It is harder than you might think to communicate things like height, weight, and size—but it's important.

Close-Ups

Close-up photography with a normal DSLR can be fairly expensive due to the cost of the lenses. It can also be challenging to get a large camera in close—and keep it still. Also, you need to get a fair amount of light onto the subject you

are photographing to allow for greater depth of field in the image.

When you photograph close-ups with a macro lens on an iPhone, the problems outlined above disappear. Place your camera close to the subject, tap on the screen to focus, and capture the image. With the iPhone, all you really need to worry about is making sure that neither your hand nor the phone casts a shadow on the subject. If a shadow does appear, simply change your camera position to resolve the problem.

Water

When you are taking photos with water in them, you have to contend with high exposure spots, the movement of the water, and the darkness of the water. However, you can get amazing photos if you assess the exposure properly.

This is a perfect time to rely on the exposure controls your iPhone camera offers. Tap on a

◄ *top*—There is detail in the shadow parts of the water, but none in the highlights. This image was made with my iPhone 3. Today's cameras and HDR apps produce better results.

◄ *bottom*—Here, the sun was behind the camera. The exposure works.

▼ I had to take this photo about twenty times before I had something I liked. The boat was rocking like crazy, and it was difficult to get the shot in focus.

Your camera will work hard to get the overall midtone exposure. As a result, highlight areas will end up with little to no detail.

midtone area of the image first to see what type of exposure you can obtain with those parameters. Sometimes you will lose detail in the shot if your exposure is too bright.

A Rocking Boat. When shooting on a boat or a dock, you must take into consideration the movement of the boat or the scene around you. To get an image that is in focus, try slowly moving the iPhone camera with the object while taking the photo.

Water in the Background. When you have water in the background of your scene, you can end up with a variety of surfaces, all with different exposures. At first, your camera will work hard to get the overall midtone exposure. As a result, highlight areas will end up with little to no detail. This won't do. A good exposure holds detail in the brightest and darkest areas in the frame.

Bouncing Light

As I have mentioned before, reflectors or cards can be used to bounce light onto a subject to bring up the overall exposure value or fill in (i.e., lighten) dark shadow areas. Sometimes, adding fill light means that you can avoid moving the subject or altering your composition. There are several kinds of professional reflectors available on the market. However, you can also use sheets of foam core (available at craft stores) to bounce light. Even a light-colored wall can

reflect the light you need to fill in dark shadows or raise your exposure. As a professional, I use all of the resources at my disposal.

Colorful Compositions

Sometimes color itself is the subject of your image. Such was the case with this image of

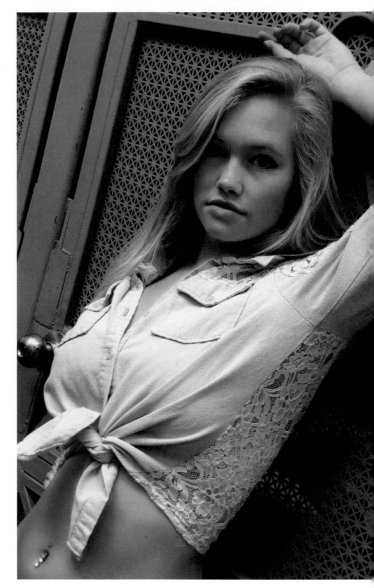

▲ I asked the model to stand a little closer to a bright wall so that the light being reflected from it would fill in the shadows on the darker side of her face.

Don't forget, you will need to have model releases for any people you photographed. You'll also need releases for any recognizable objects, products, or buildings.

Silhouettes

Taking a silhouette with the iPhone is more difficult than you might expect, as the camera's sensor wants to choose an exposure based on the midtones. The first thing you need to do is force the camera to expose for the brightest spot in the frame (simply touch the area of the screen that contains the brightest tones). This

chalk. I used the ProCam camera app to capture the shot. I then pulled the photo into EyeEm and used the Color Punch filter. I brought the photo into Photoshop to create the final, higher-resolution image for print. This photo is now available for sale in the EyeEm/Getty stock photo collection. Sure, using EyeEm will help you create amazing photographs, but you can also use it to start selling the amazing photos you take with your iPhone camera.

should make all the dark areas in the frame go to black, or close to it. In iOS 7, tap the screen to choose the exposure point to create this effect. In iOS 8, tap the screen to bring up the exposure slider, then find the exposure that gives you the proper effect. With this accomplished, you will see the beginnings of a good silhouette on the camera screen.

Avoid allowing bright light to wrap around the object you are trying to make a silhouette out of. If that happens, you will see some detail in that object and your shot will look more like a poorly exposed photo than a silhouette.

Once you have taken the photo, you can go to your filter apps and explore various creative possibilities.

Panoramas

The iPhone has changed the way a panorama is taken. It used to be that you would place your camera on a tripod, take a photo, turn the camera 15 degrees and repeat until you had all the photos you needed to capture the scene. Then you would use professional image-editing software to stitch your photos together and hope for the best.

With the iPhone's panorama mode, you can literally press

Start, turn your body while keeping the arrow that appears on the screen right on the line, and get an amazing panorama. The main thing you must remember is that your iPhone can distort moving people and animals—and I mean *really* distort. However, I have included a sample

▶ Here is an interesting example of using the silhouette technique. You can see that the background is bright and the details in the subject are not apparent. However, the light did stream across the steps, allowing for the top of the step detail to show through. The image contains various textures and surfaces that engage the viewer. I opened the image in TaDaa to enhance the contrast and vibrance. I then added an oval blur to the image to soften the corners.

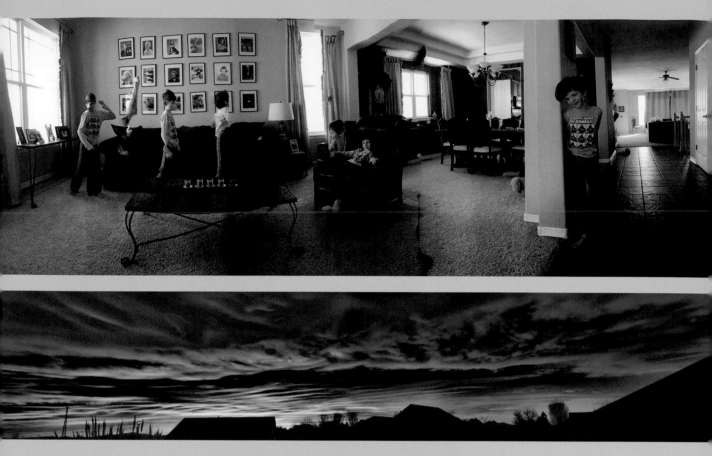

▲ *top*—This concept is super cool, even if the kid's head is distorted. I think that, had I photographed an older subject who was able to stand still, I'd have ended up with an undistorted subject who appeared in multiple areas of the image. Remember that once part of the image is captured, the subject is free to move around.

▲ *above*—The panoramic technology built into the iPhone still amazes me. Creating a panorama of this scene with a DSLR would have required hours of work in Photoshop.

panorama in which it seems that the camera ignored the subject's motion. Once a portion of the image is captured, a subject in that part of the frame is welcome to move into the shot again. This image shows the human subject moved from place to place in the frame while I recorded the panorama. This is lots of fun!

> **Once a portion of the image is captured, a subject in that part of the frame is welcome to move into the shot again.**

Black & White

Black & white photography has been around since the dawn of photography. As an iPhonographer, you have an advantage over photographers of the past. You can preview the image on your screen before you capture the shot. This ability will only elevate the art form.

Another advantage to capturing black & white images with the iPhone is that there are many apps on the market that will allow you to alter the contrast and depth of exposure of your black & white shots.

I enjoy displaying my black & white iPhone images in my home. I can change the artwork periodically for very little money. It's difficult for department store and drug store photo labs to get good black & white prints from their machines. It is even more difficult to get good black &

white prints from your home printer. I recommend that you have your images printed by a professional lab. I get great 11x14 inch prints for about $2.00 each. That's an amazing price, and the tones are perfect. Try a lab for printing your color images too.

Landscapes

Keep It Steady. In landscape photography, exposures can be anywhere from $^1/_{1000}$ second (very bright landscape) to several minutes (very dark or nighttime landscape). To avoid camera shake (and a blurry image) when using long exposures, always mount your camera on a tripod. If using a tripod is not possible, try to rest your camera on anything that will provide support, like a fencepost or the roof of a car.

You might not be able to blow up a landscape photo captured on your iPhone to 16x20 or 20x30 inches, but you can print a quality 8x10. With an iPhone 5 or 6 and iOS 8, you can you print an 11x14 that shows amazing detail.

Learn from Others. It's easy to get stuck taking the same sort of photos day in and day out. Try to vary your technique or approach

▼ This photo is gorgeous. I love the bright, detailed and vibrant green lower two thirds of the image, then the mountains in the mist in the background. The trees line up almost perfectly along the upper third and middle of the image.

▶ top—Here is another image composed using the rule of thirds. All of the interest is in the top third of the image. The negative space in the lower two thirds of the image is sublime. The added detail of the water rippling was created by throwing a stone into the water.

▶ bottom left—Taking this photo made me see just what the iPhone camera is capable of. The detail in the exposure is amazing. If you look at the bottom-left of the image, you can see the detail in the dark water. Wow! The colors in the shot are also amazing to see in any setting. These colors are capture-ready during the magic hour in the early morning.

▶ bottom right—Not every landscape image needs to depict a natural scene. This industrial landscape seems to tell the story of an outpost on a deserted planet.

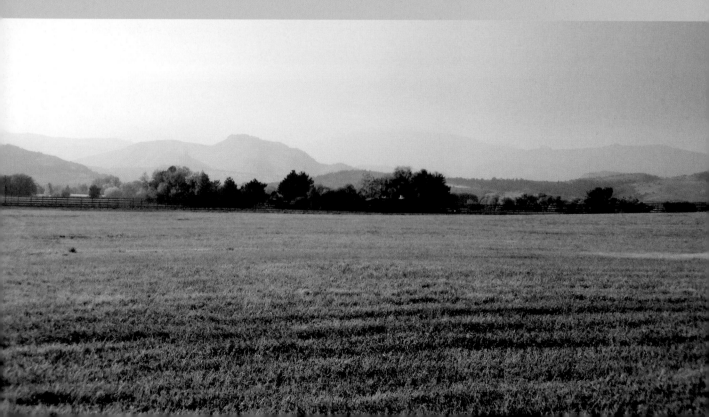

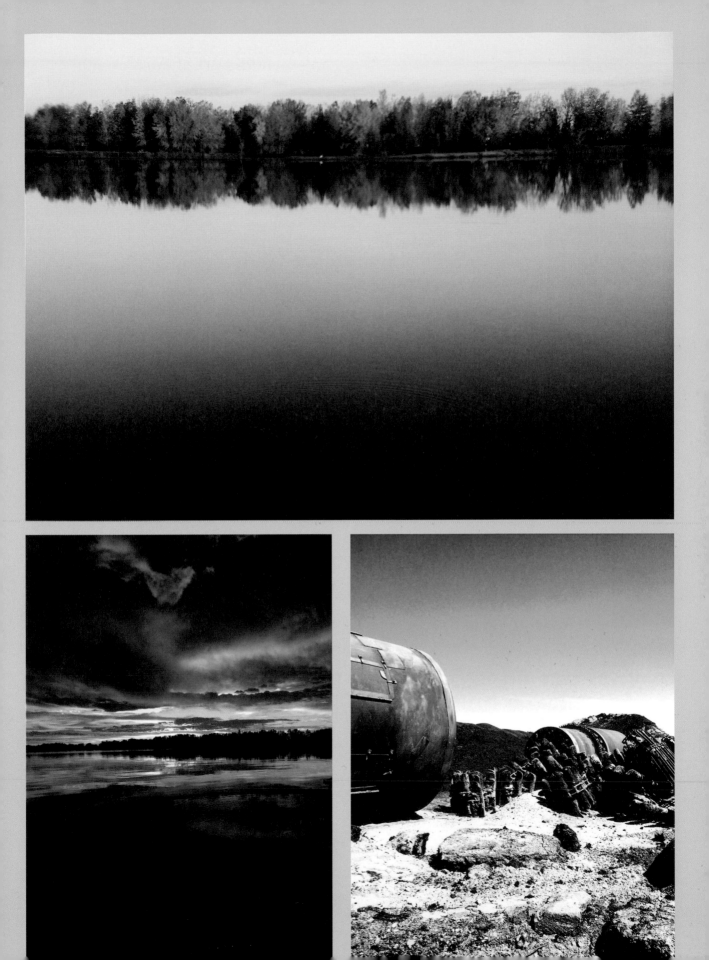

scenes in a different way to get photos that are different from the rest. Get inspiration by looking at other peoples' photographs; do not copy them, but aim to get different ideas that you can use when you're in a similar situation.

Create Foreground Interest. Try including an object in the foreground to add appeal to your images. Sometimes we focus too much on the main subject and forget about what's in the foreground. Including an object like a rock or bush can add another layer of interest and help lead the viewer's eyes through the frame. Foreground elements can also be included to help you achieve a more balanced composition.

Leading Lines. Leading lines direct the viewer's gaze. Try to compose your scene so that features like roads, railings, railway lines, streams, shorelines, etc., run from or near your foreground and toward the main focal point.

Know the Story of the Landscape. They say a picture paints a thousand words, and yours should too. Before you take a shot, think about what you are trying to convey and why. Creating a photo with a story behind it gives your picture more meaning, and the viewer will be more interested and take more from it.

Use the Rule of Thirds. Use the rule of thirds so that your foreground and main subject fall on the imaginary thirds lines. This helps achieve a balanced composition and makes your scene easier on the eye. See pages 47–48 for more information on the rule of thirds.

Get an HDR App. The best thing you can do to take great landscape photos with your iPhone is to purchase an HDR (high dynamic range) app. HDR photogs contain a wider and deeper range of colors (basically, a range of exposures and their inherent data are combined to allow for an image with increased visual

An essential part of the learning process is hearing what others think about your pictures. Feedback, whether positive or negative, will help you gauge how your photography is progressing.

information). With an app, you can take your images from ordinary to awesome. HDR apps are affordable and worth every penny.

These Rules Are Perfect, So Stick to Them. Unless you're supremely confident in your photography, stick to the rules and guidelines. Breaking the rules can give some of the best results, but don't just ignore them without knowing why you are doing so. Once you know the ropes and can understand why you would break a particular rule, the world is your oyster.

Get Feedback. An essential part of the learning process is hearing what others think about your pictures. Feedback, whether positive or negative, will help you gauge how your photography is progressing. Upload what you think are your best shots to photo sites for some feedback; you may be surprised to find that what you think is a good photograph could use some improvement. Also, there's no point taking great photos if they are stashed in your hard drive and forgotten. If you have some nice shots, show them to your family and friends and/or print them and display them on your walls for all to see.

▶ You need an HDR app of some sort to get the perfectly exposed snow and rich colors you see in this image. Notice the detail in the snow and the water. It is truly amazing.

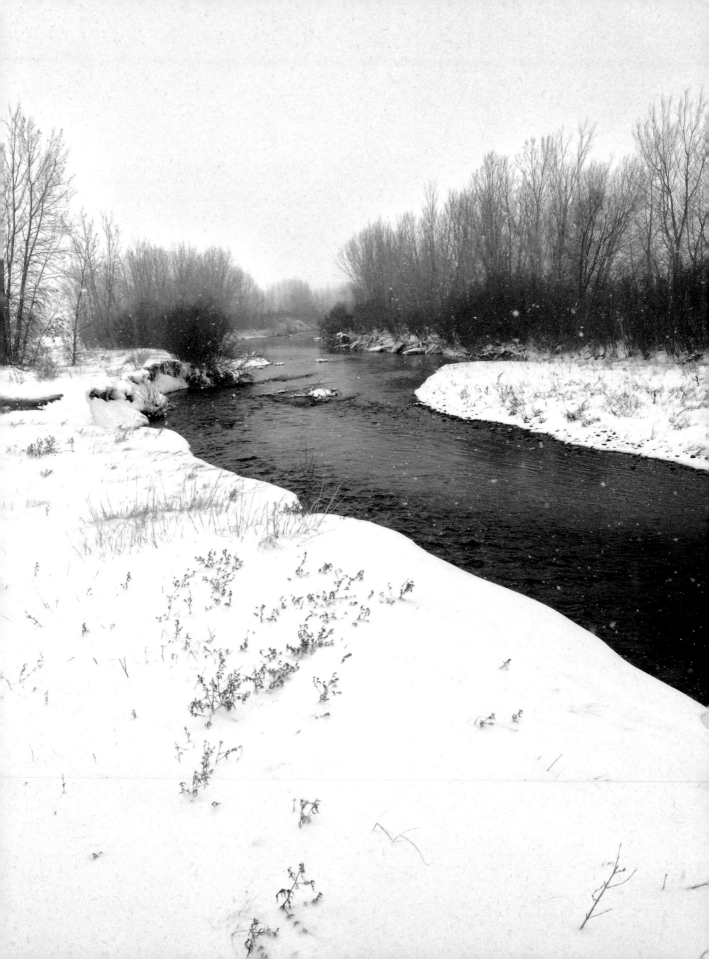

◀▲ These images prove that your still-life shots do not need to consist of flowers and fruit baskets. The matches were photographed larger than life; the composition is comprised of interesting lines, shapes, and color. This crystal drink set was photographed outdoors in bright sunlight using the True HDR app.

Still Lifes

Still life photography dates back to the dawn of photography. It is an amazing means for studying composition, lighting, and framing.

Creating a successful still life requires a tripod—and the appropriate adapter for attaching your phone to the tripod. You can use accessory lenses, but it's not required. Simply set up something that interests you, take the time to carefully frame your subject, move the subject(s)

around to create a strong composition, and play with the lighting and exposure. When things look good, take the photo. This is a great time to experiment. Take the same photo using a variety of apps and see how the results differ.

iPhoneography Series

When I was in school, I had several assignments involving creating a unique series of images. By series, I mean a group of three or more images

that work together. A series might be comprised of numerous photos made at a festival, various images of the same person, or a red ball in three unique locations. The subject matter is up to you. Push yourself as an iPhoneographer and create some amazing image series.

Modeling Portfolios

So many people want to get into the modeling business. Yes, professional photographers can take amazing photos of models, and for the right price ($3500 and up), models can hire high-end photography teams and a makeup artist. But we iPhone photographers have an advantage: people usually look best in photos when they are relaxed in front of the camera, and with an iPhone, you can shoot unobtrusively.

The images in this section were created specifically for this book, but they show that it is possible to create portfolio-worthy images with an iPhone. With a little practice, you can create an awesome modeling portfolio for your clients. For the best results, make sure the model's makeup accentuates her features, ensure she is dressed fashionably, shoot outside on a cloudy day, shoot in awesome locations, take lots of photos, and apply various filters on your best images.

Kids' Sports Portraits

Morrissey & Associates offers a youth sports portrait service. We go onto fields and into gymnasiums and take photos of thousands of children, and their teams, in their uniforms. To take these photos properly and have them printed properly requires the know-how of a professional. However, for parents looking to take pictures for friends and family, the iPhone camera is perfect.

When shooting outdoors, try to keep the sun out of the athlete's eyes. The sun makes people blink, squint, and make faces. Also, take a minute to get a good pose. When the subject is well-posed, these

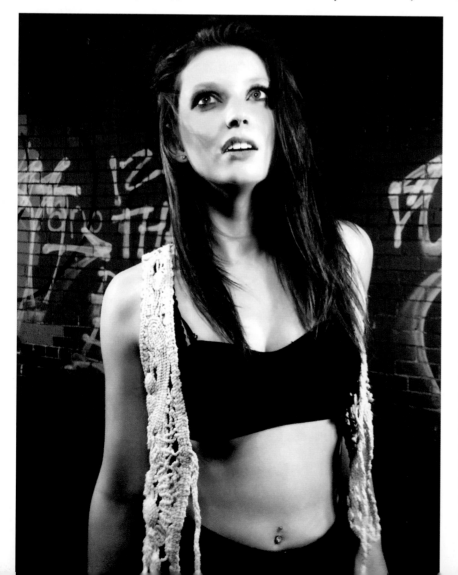

◄ Five lights were used to capture this modeling shot. The image was shot outdoors, at night. It proves just how sensitive the iPhone chip is to light. The wall was a good twenty feet behind the model, and there were two lights pointed at it. ► I like the colored lights with the dull colors of the model. The blur was created in TaDaa, and the color effects were done in EyeEm.

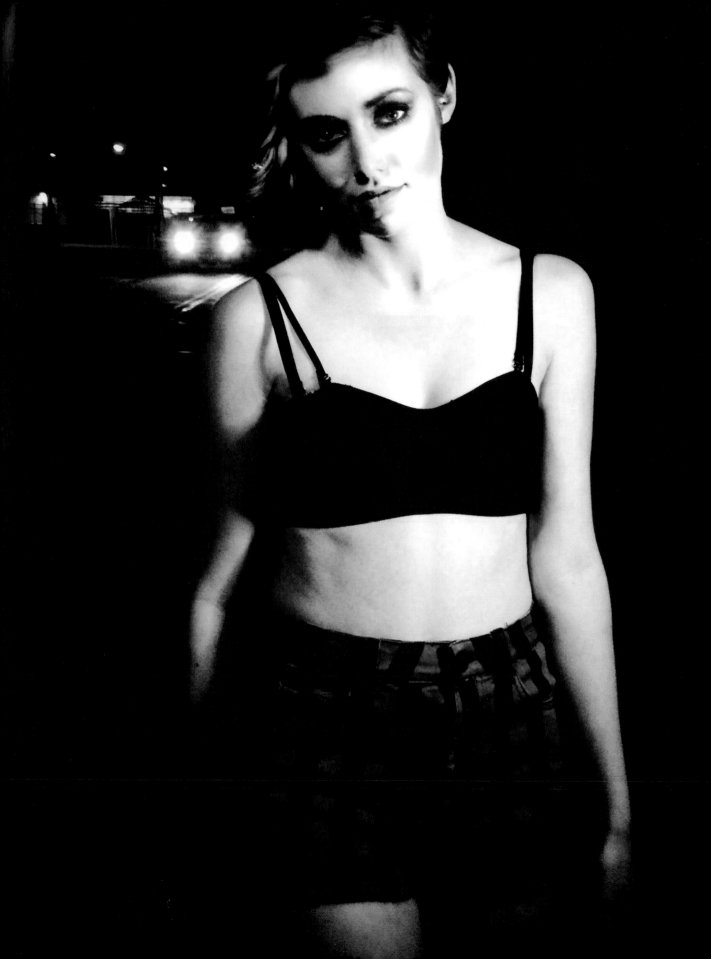

▲ This great image is comprised of three photos taken with MegaPhoto effects. I absolutely love the humor the effect brings to this image.

images can look great. Ensure that the subject is compact in the frame. For example, have the subject kneel, or simply zoom in on the subject so that the individual fills the frame. Finally, adjust the exposure for the best result.

For courtesy's sake, never step between a contracted, professional photographer and an athlete when the hired pro is taking pictures.

Selfies

Everyone takes selfies these days. There is little advice I can offer here—just find the best light, look into the lens, make sure you look good, then capture the image. If you don't like what you see on the screen, just don't take the photograph.

Experiment with apps and play. I suggest that you look at my selfie on page 7. I try to have a little more fun with my selfies than most people seem to.

Have the subject kneel, or simply zoom in on the subject so that the individual fills the frame. Finally, adjust the exposure for the best result.

10. Artistic Growth

These first few tips in this chapter are intended to help you get into the proper mind-set when taking a photo. Yes, I did say mind-set. You can't just look into the viewer, take a photo, and expect it to be the best it can be without taking some time to really think about what you are doing.

at a time. Spend time applying the rules written in this book and keep practicing, researching, and doing everything you can to improve that particular aspect of your photography. When you feel confident in your abilities, move on to the next area of your work that needs your attention.

Learn Where You Need to Improve

To grow as an artist, you must figure out what you need to work on. Creating a mental list of the things you don't feel confident with is a good place to start. Your list can be as long or as short as you like, but try to be as focused as possible. Remember, you don't need to share your list with anyone, so be honest with yourself.

When you have your list, concentrate on just one topic

▶ This was the first test shot I took with the True HDR app. The colors are amazing, and the way the sky and the glass are exposed sell me on the quality of this app's abilities. I used the Darkroom app to blur the edges of the image.

Be Critical

When you take a photograph that you're not happy with, don't just scrap it. Figure out what it is that you didn't like. Keep the duds so you can look over them later. You might find that you are making the same mistakes over and over again. If that's the case, add the issue to your list of skills you'd like to improve upon.

Create Self-Assignments

Give yourself photo assignments. This is a great way to improve your skills, and it can be a lot of fun. Say you decided to assign yourself the task of photographing every coffee cup you see in a week. The challenges would vary, and in working through them, you would build your skill set. You have already made a list of things you need to improve, so why not jump right in and assign yourself the task of creating a photo series that will help you improve on something

that has been difficult for you? Taking on your assignment will help get you on the right path to taking great pictures. Make sure that your assignment is achievable and, preferably, something that you will enjoy doing. Photography, in part, is about having fun. Sure, you want to improve your shots, but don't just take a thousand photographs of your fish; do something that will take you out of your comfort zone.

Try New Things

The worst thing you can do is take shot after shot of the same old thing, with the same old settings. If there's something you're brilliant at, then tuck that under your belt as an attaboy and keep the ball rolling. Change things up to make sure you don't get complacent. You never know what you might get if you don't try new techniques. You might learn something that will further a skill you are already good at, or you might improve another facet of your photography. It is important for beginners to understand that trying new things will speed up the learning process.

Be Patient as You Learn

I'm not so good at being patient, but it's an important trait! Don't expect amazing results instantly. Becoming a good photographer takes time. It isn't something that can be learned overnight. When you are working through your assignments, don't give up at the first sign of failure. I cannot emphasize this enough: simplicity and good composition make for great photos—even of everyday subjects.

◄ I cannot emphasize this enough: simplicity and good composition make for great photos—even of everyday subjects.

▲ This image makes the case that the iPhone 6+ is capable of producing fantastic black & white photographs. The gray tones in this photo compare to any film exposure. This image is unedited; it is straight out of the iOS 8 camera app.

Finding Inspiration

Once you are feeling confident with your iPhone, you might feel like it's tough to break new ground. Try to look to other people's photography for direction. The Internet is filled with photos taken with iPhones—and iPhone images are making their way into magazines and onto signage. Try taking ideas from the photos you see rather than copying them. This way, you can develop your own unique style.

Learn from the Pros

Find your own photographic heroes. Critiquing another photographer's work is always easier than critiquing your own. Try to see why a particular shot is so good, and ask yourself what their photographs have that yours don't. This is a great way to improve your artistic vision. As you look more closely at other photographers' work, you will see that you have talent. You just need to hone your abilities.

Shoot, Shoot, and Shoot Again

There's no better way to learn photography than to get out there and experiment. You can read all the books in the world, but you will learn faster from your own mistakes. Take shots of the same thing over and over again in different ways. I personally have taken hundreds of thousands of shots so far, and I still see myself as a student of photography.

Listen to Feedback

When you are trying to improve your photography skills, don't be afraid to ask other peoples' opinions about your work. There are plenty of people out there who are more than willing to give you an opinion, and it offers you an opportunity to see your work through someone else's eyes. Let people know you don't just want to know whether or not they like a photograph, but what it is they do or do not like about it. To get a well-rounded opinion of your photography, don't just ask photographers for feedback—ask for the opinion of everyone who matters to you. Even a non-photographer may help you see something you could have done to improve the shot, so be bold and get feedback from as many people as possible.

Never Give Up

The most important tip of all is never to give up. If you want to be an amazing photographer, you'll need to accept the fact that it takes a lot of work. Everyone has to start somewhere. Now that you have an incredible camera in your iPhone, and it is always with you, stick with it and you will get there. Try to have fun, and always remember that you are capturing moments in time that you can look back upon in future years with a smile.

◄ Sometimes you need to change your camera angle to make something mundane look exciting. I blurred the top of the image and enhanced the color in TaDaa.
► Small subjects recorded larger than life are fun for the eye to meander through. The muted tones in this image were achieved through the EyeEm app.

Enjoy Yourself

When learning to take better photos, it is always important to try to enjoy yourself—even if you are serious about becoming the best iPhone-ographer you can be. Sure, there are countless people using iPhones to take photos. Try to remember that you are not in competition with them; rather, you are in competition with yourself. Do your best every time. Don't allow yourself to become frustrated. Just relax, enjoy yourself and your photos, and be the best iPhoneographer you can be.

▼ The iPhone 5s is the perfect camera for captuing journalistic shots. It is accurate but small and nonthreatening.
▶ *top left*—I used TrueHDR for this shot in the Boulderado hotel. The highlights, midtones, and shadows are well exposed.
▶ *top right*—I was able to sneak up on this bird with a small camera. The result? A shot with great color and composition.
▶ *bottom*—My iPhone 6+ blows me away. We were moving 15mph up the mountain, but the photo has great clarity and color.

11. You Can Do *What* with That iPhone?

White Portrait, Pink Flowers

Your iPhone can be used to create highly stylized, conceptual, professional portraits like this one. Let's look at the steps I took to create this image.

The Lighting. This shoot took place in my garage. I attached a 6x6 foot Chimera scrim to two light stands. I placed the scrim-and-stand setup at the edge of the garage so the setting sun would illuminate the fabric, rendering it a solid white. I used a 4x8 foot white bounce card on the right side of the model. A studio strobe with the modeling light on full power was posi-

tioned on the opposite side of the model. The strobe was inside of a 2x4 foot Chimera strip softbox, about three feet from the model, and it illuminated her fully.

I set the iPhone on my tripod vertically. In the 645 Pro MK III app, I selected a film style that would mimic Fujichrome. I attached my Schneider telephoto lens and captured the image.

The image was processed in Photoshop. I did more to the shot than you might think, but I never changed the overall concept or file quality. I removed shadow areas on the scrim where it didn't go completely white. I removed the staples in the headdress that held it together. I even removed the top the model was wearing so that it looked as if she had posed in less clothing. I pushed the color of the flowers in her hands to a softer pink and added the pink fairy dust wisps that create a sense of movement in the image.

The file from my iPhone was huge and had great resolution. I was able to work in Photoshop freely and never had to worry about resolution, gamma, or color density. The image can easily be printed at 16x20 inches and look great. This and other shots in this book prove beyond the shadow of a doubt that the iPhone camera can compete in the daily photographic marketplace.

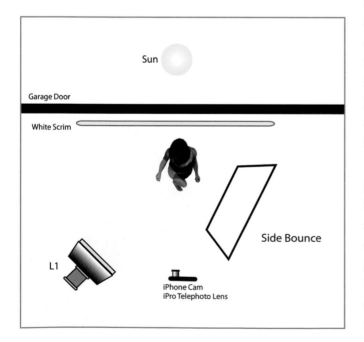

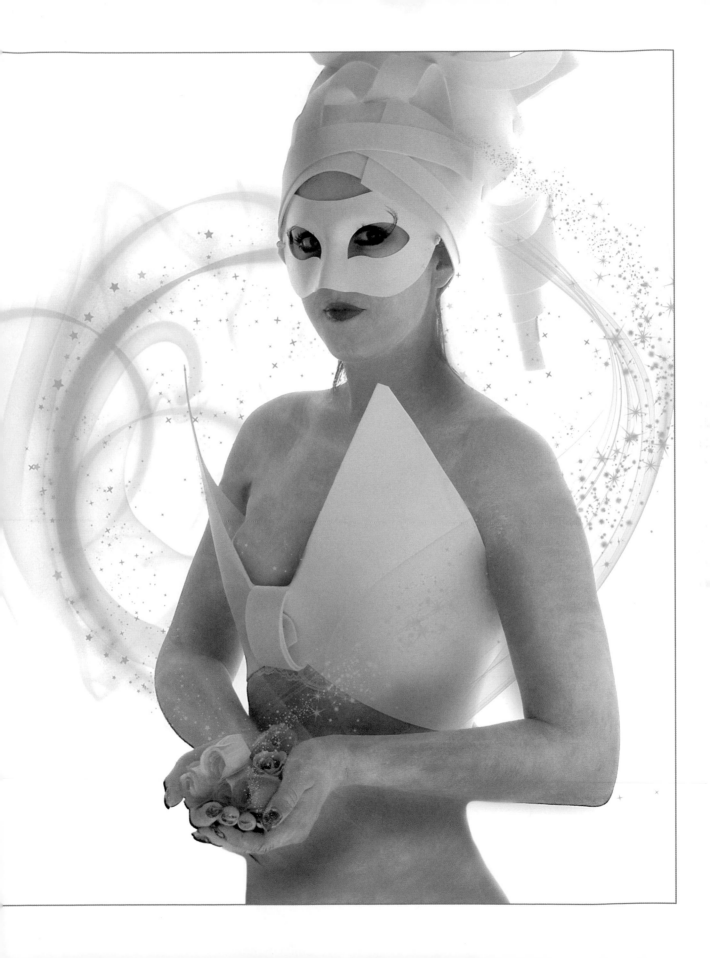

Stunt Double

Studio work can be demanding. You want a camera that offers complete control over your focus and exposure, one that is easy to operate so that changing settings will not lead to a break in your focus or creative flow. You also want to be able to shoot from tricky angles when the need arises. The small and lightweight iPhone is pretty easy to maneuver. It rises to the occasion and meets all of my professional-photography criteria: it is simple to use and provides predictable results, full exposure control, depth of field control, and lens control. It is durable, upgradeable, and offers good resolution. No, the resolution is not on par with the resolution capabilities of professional cameras, but I can use my iPhone camera's images in most of the professional mediums (print, web, and e-mail) perfectly fine without anyone knowing they were "only taken with an iPhone."

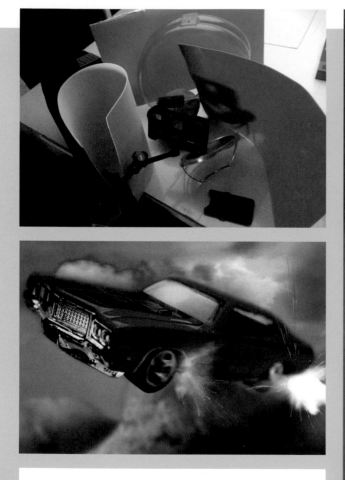

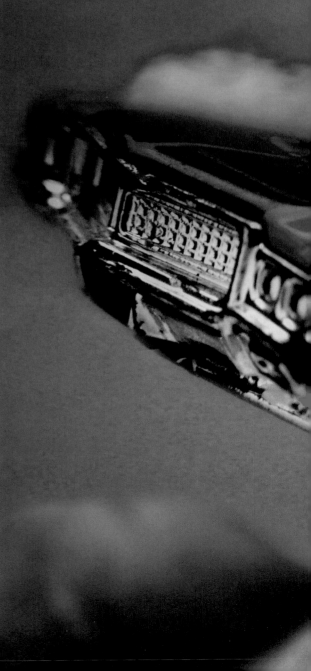

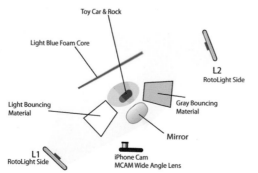

Toy Car & Rock

Light Blue Foam Core

L2
RotoLight Side

Light Bouncing
Material

Gray Bouncing
Material

Mirror

L1
RotoLight Side

iPhone Cam
MCAM Wide Angle Lens

Photographing this toy car was the perfect test for the iPhone camera system. The car was only 2 inches in length. I needed to get depth of field on the toy car while finding a great angle to show off its lines. The lighting had to be dead on and the focus was delicate, to say the least. I knew I would be compositing the car onto the background image, so there would be some work required in postproduction. However, I felt that the success of the final image depended primarily on the proper capture of the car.

I used the mCam lens system. To get close to the car, I selected the macro lens from the kit. I attached an articulated arm to the mCam housing and then connected the arm to my tripod. This gave me more flexibility when trying to get my macro camera angles.

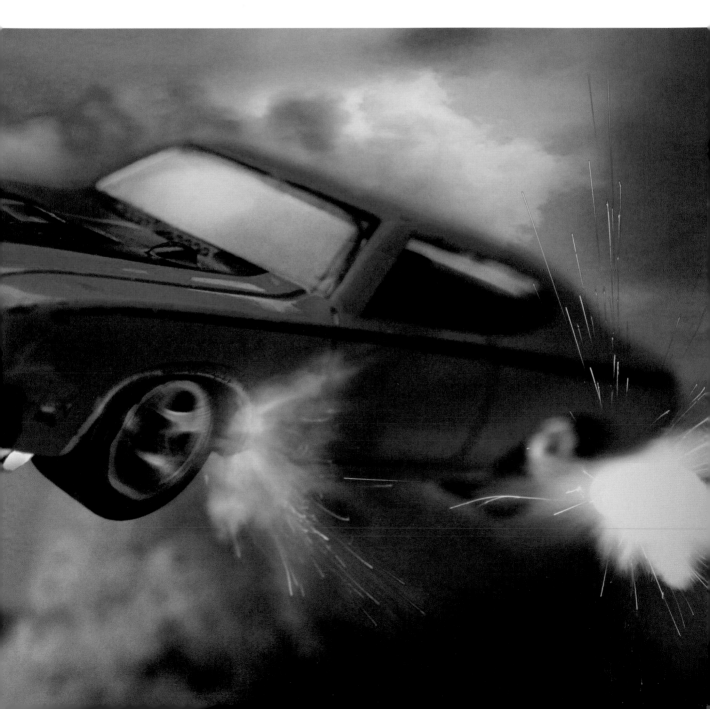

Look in the Sky

This photograph was taken at night. The main light was a large bright light positioned above the children and at a 45 degree angle, just outside of the door. I also used three LED lights for fill to bring out some of the detail in the shadow areas. The LED lights were bright but did not compete with the power of the main light.

I used the Schneider telephoto lens to get that long-lens feel and took the shot. Next, I opened the original image in EyeEm and applied the filter that gave me the look and feel I was after (I usually use filters in the Urban collection). I saved the shot to my camera roll and e-mailed it to myself. Finally, I opened the image in Photoshop, changed the image size to 8.5x11 at 300dpi, and saved the file. (*Note:* I practice what I preach. The images below are other shots I took during this session—they didn't make the cut. The final image has the lighting and emotion I was looking for.)

The main light was a large bright light positioned above the children and at a 45 degree angle, just outside the door. I used three LED lights for fill to bring out detail.

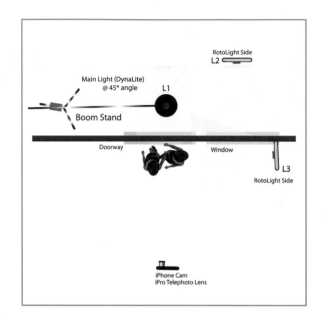

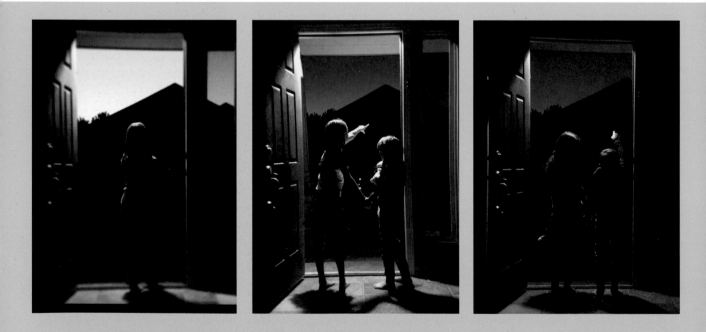

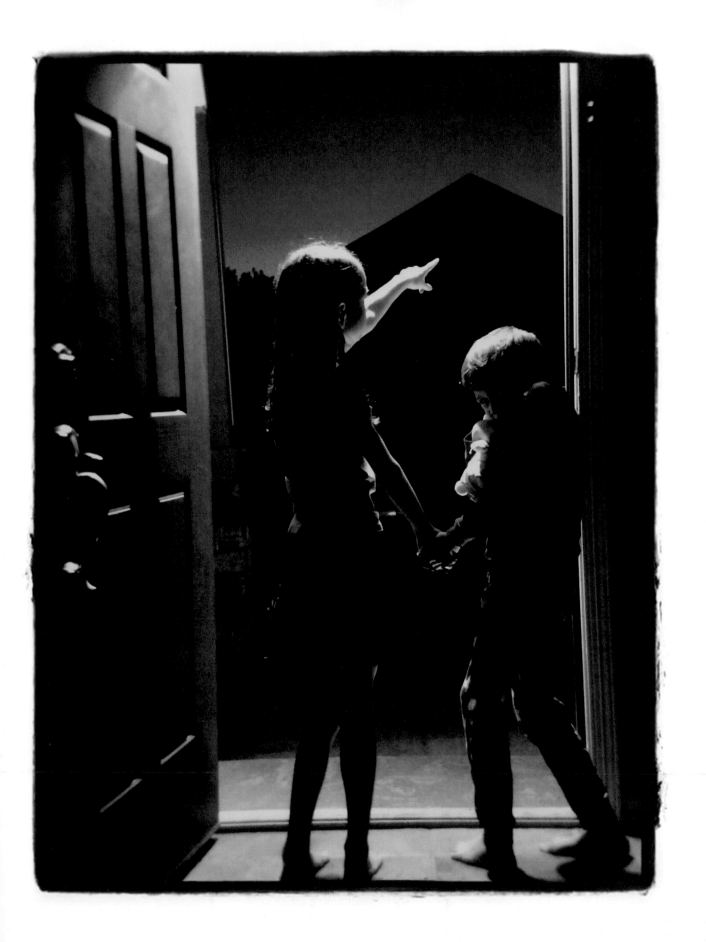

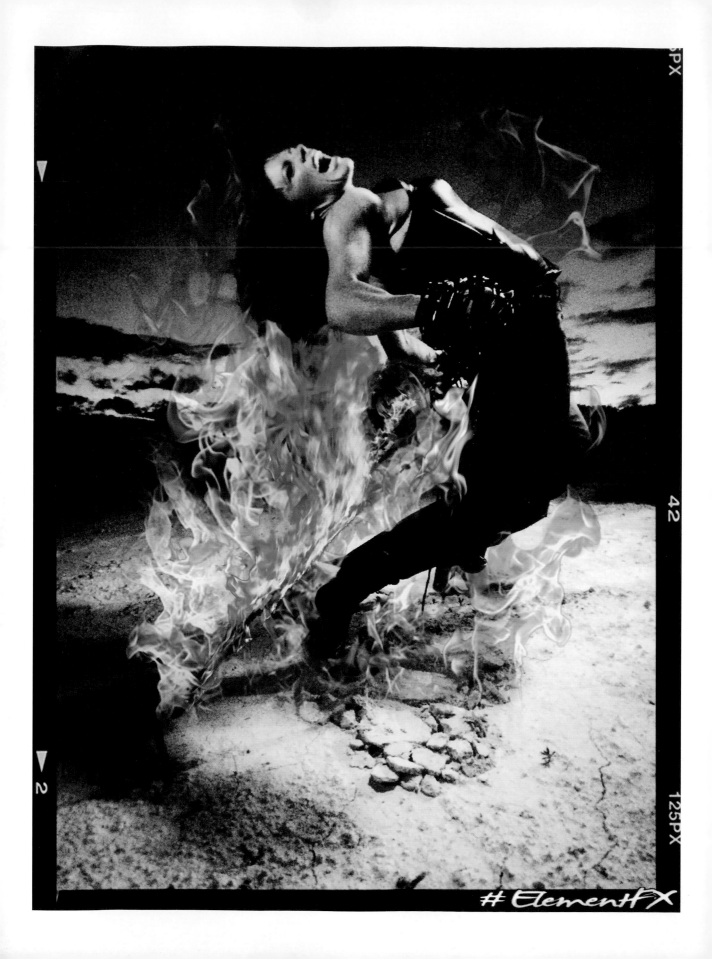

Fire and Chains

The iPhone is more sensitive to light than a DSLR. This means that with my small and portable LED lights, I can light an image with less wattage than would normally be needed to create the same image with a DSLR. The only setback when creating a shot like this is, for maximum control over the lighting, the photo environment needs to be very dark. This way, I can add the light I want to the scene without dealing with light I don't like. When shooting outdoors, I need the sun to go down before I can start taking photos. The iPhone's camera is so sensitive to light that even as the sun is setting, the shot appears to have been made in daylight (you can see evidence of this in the featured image).

I have included a schematic of the lighting which shows where the lights were placed to get the final image.

With my small and portable LED lights, I can light an image with less wattage than would normally be needed to create the same image with a DSLR.

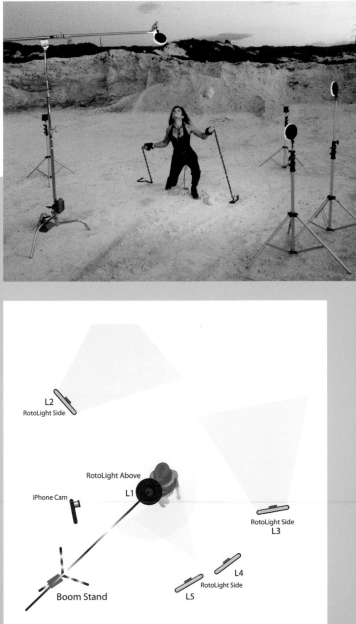

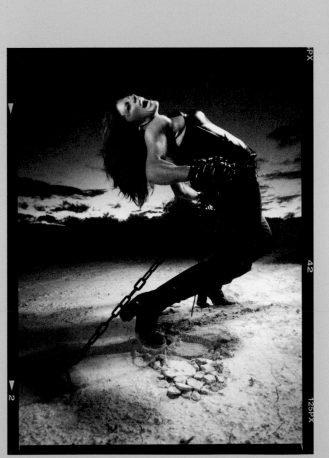

L2
RotoLight Side

RotoLight Above

iPhone Cam L1

RotoLight Side
L3

L4
RotoLight Side
L5

Boom Stand

Blue Gentry

This image was also taken outdoors at night. Once again, due to the light sensitivity of the iPhone, I was able to illuminate the train track and the part of the landscape with only two LED lights on studio stands. I used one LED on a light stand up high and to the front left to illuminate the mandolin player. As you can see, the musician's movement was frozen and the image is sharply focused. This is because there was plenty of light for a fast exposure. I used the 645 Pro MK III app and the iPhone camera's iOS 7 app to capture the moment. The 645 PRO MK III app allowed me to control the f-stop, shutter speed, and ISO for a perfect exposure. Using this app allows me to work like a pro with my iPhone's camera.

Next, I turned to the EyeEm filter and chose a color-enhancing filter. With that ac-complished, I opened the photo in Photoshop. If you take a close look, you will notice there are a few bright mushrooms in the photo. The mushroom shots were taken with my iPhone 3 camera during a nighttime parade. I simply created a new layer containing the mushrooms, then transformed that layer to a small size. I used the Eraser tool with a small brush setting and 80% hardness so I could remove the background information with precision. Once I had finished adding the mushrooms, I created another layer just below the mushroom layer. I used the Brush tool to paint in black shadows. I set the shadow layer to 50% opacity. Once I was happy with the shadows, I saved the file as a JPEG, e-mailed it to my phone, and opened the file in EyeEm a second time. By running the photo through this filter app twice, I was able to get the amazing color seen in the final image.

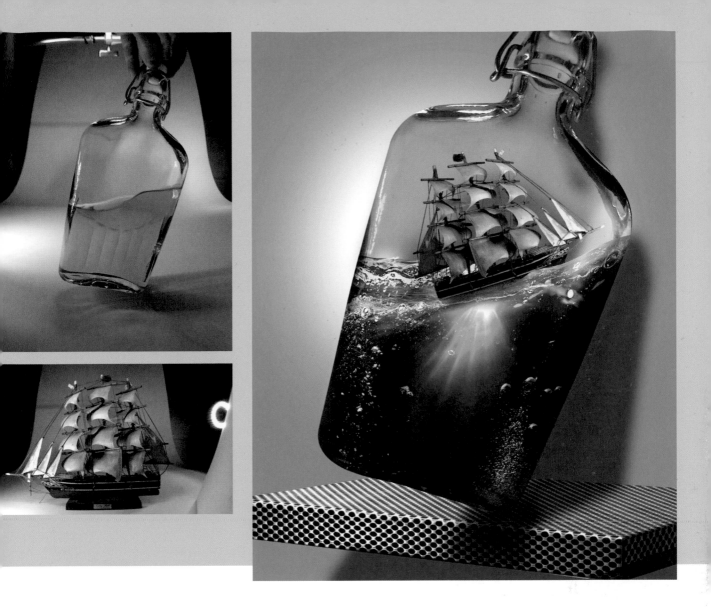

Setting Sail

My original photos (a ship, then a bottle on a clean background) were taken with the iPhone. I then removed those subjects from the backgrounds and placed them on individual layers in Photoshop. I blended the objects together, then cleaned up the image.

I created a green layer in Photoshop to serve as the background. The bright light effect behind the bottle is just a white circle that was heavily blurred using the Gaussian blur filter,

then placed bewteen the bottle layer and the green wall layer. I painted the shadows onto the wall using the Brush tool, then changed the opactiy of the shadow layer to 30 percent to make it look like a real shadow. The water in the bottle was added using Ron's Waterlines. The shelf is a stock photo that I warped into a shape that worked for my image.

Off the Hook

This is where I really start pushing the boundaries of the iPhone camera and the files it creates. This photo follows in the footsteps of many professional photo illustrations produced by my studio. There is almost never the need for a mundane, simple shot without manipulation of some sort. So, as a true professional, to truly test the iPhone camera, I had to put it through the rigors of a professional photo assignment. The good news is, the iPhone passed the test. The bad news is that re-creating an image like this requires that you really know your way around Photoshop.

To start off, I drew out the image I intended to create using pencil and paper. This gave me a good master plan for photographing the separate parts of the shot. I placed each subject on a white Formica sweep so I could control the color of the background. (This makes it easier to remove the object later in Photoshop.) Then I photographed the fish, the fish bowl, the table, and the hook separately. All of these photos were taken with the iPhone using the ProCam app.

I then photographed the fish bowl with only the rocks in it. The water was added in Photoshop using a third-party brush and texturizing program called Ron's Waterline.

To remove the main portion of the image (fish, fish bowl, hook, and table) from the background, I used the pen tool. With practice, this is the most accurate way to select an object from any background. Once each object was on its own layer, I brought all of the elements into one main working file.

This is where I really start pushing the boundaries of the iPhone camera and the files it creates. This photo follows in the footsteps of many professional photo illustrations produced by my studio.

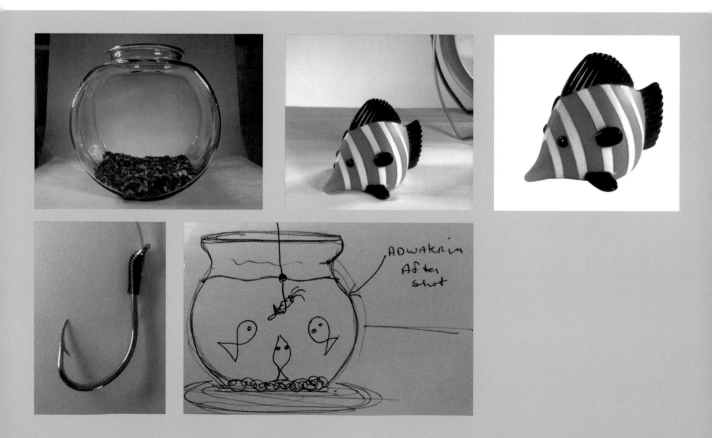

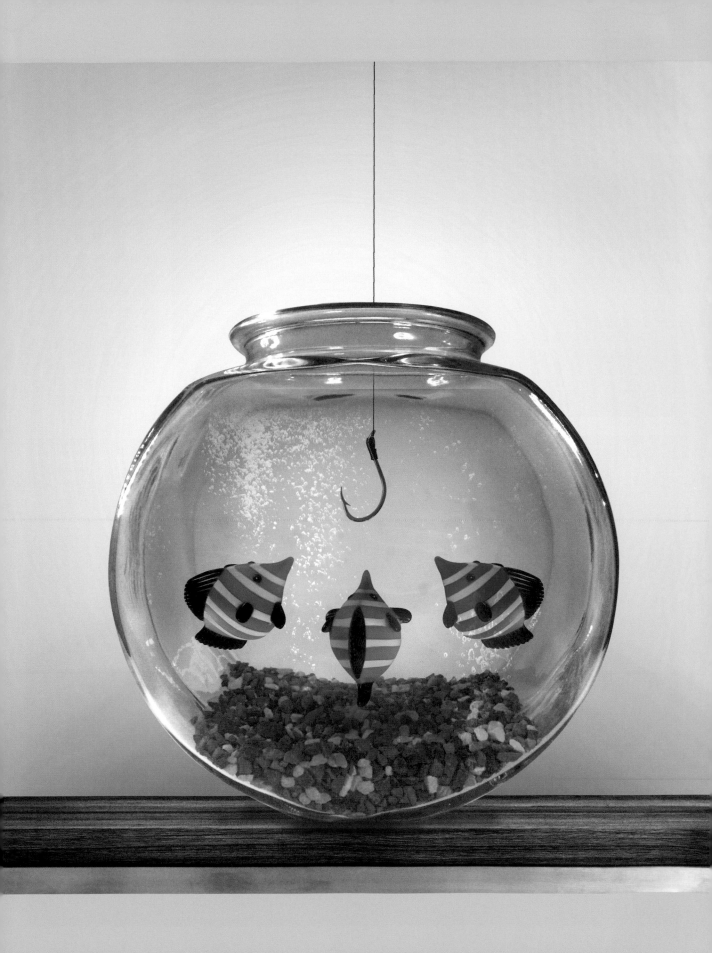

◄ *top*—This image is a testament to the iPhone's flexibility and speed. The clouds had covered the moon and the sky was completely black just seconds after I captured the shot.

◄ *bottom*—I love to be able to capture quick photos outdoors, in the dark. It's much easier than setting up a tripod so I can use my DSLR.

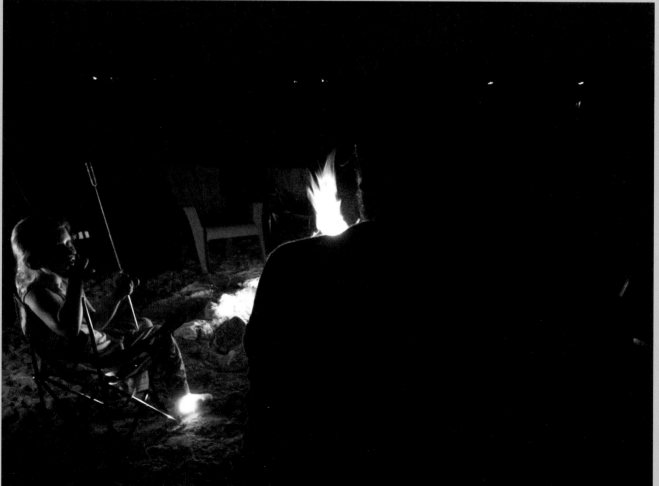

Conclusion

The Future of iPhoneography

When I was asked to write this book, I was a skeptic. Think about it: I am a professional photographer. To deliver the highest-possible image quality, I use high-end cameras, interchangeable lenses, and professional lighting. After I have the shot in the can, I edit my images with state-of-the-art software. If you had asked me, before doing the research that was needed to write this book, whether the iPhone could ever replace the DSLR in a professional photography environment, I would certainly have said *no*.

As of this writing, I have changed my tune. I used my iPhone on a commercial shoot recently. I had to take a quick shot of a nurse standing at a

computer station in a busy hospital with nurses running around everywhere. (A patient even thought my model was a real nurse and asked

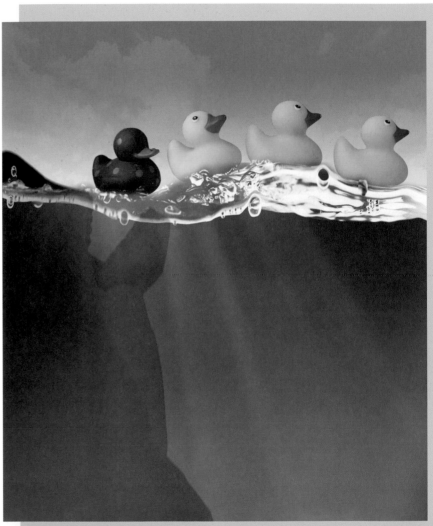

► This image (top) was created by photographing each duckling and the shark separately on set. I then used Photoshop to remove the background. The sky was from a photo I had taken a while ago. The water was pulled in from Ron's Waterline brushes and effects. With a little ingenuity and know-how you can get amazing images using the iPhone camera.

▲ An iPhone camera is an amazing, versatile device that becomes even more capable and incredible with every update.

her for a blanket. It was that busy!) This meant I could not set up a ton of lighting gear. I chose an app that gave me complete control over my exposure settings and got two great shots in just two minutes.

I couldn't believe the quality of the final image, which I have included (facing page) for you to examine. This was my first commercial shot with my iPhone, and I can guarantee that it won't be my last.

I predict that the Apple iPhone will replace the DSLR and digital point & shoot cameras in the consumer world within the next five years. It could happen faster. We won't be buying and upgrading DSLR kits, we will be upgrading our iPhones, iPods, and iPads. We will be stocking up on the third-party accessories that are in the forefront of this amazing transformation. These cameras will be highly sophisticated and simple to use. They will cost less and be lighter in weight than the DSLRs, allowing you to take them anywhere and take photos of anything. One more plus is that this is still a communication device, so you will be able to take a phone

call, get directions, check your e-mail, and so on.

I can't predict what the final look of these devices will be. However, I can predict that they will take amazing photos, offer photographic options like panoramas and high-speed capture, plus you will be able to edit and share your still photos or videos immediately after you take them. You will be able store, share, print, edit, combine, enhance, duplicate, and basically do anything you want with your images.

Yes, the DSLR as we know it is in trouble. I have worked with the latest adaptations for the iPhone. The AIM camera system by Action Life Media will blow you away. All you do is slip your iPhone into the slaving and voilà—you have a DLSR and HDV 1080i camera. You have interchangeable lenses, tripod access, HDMI lighting, and dollies. WHAT? Exactly. Now I'm not going to run down the comparisons of the lenses and the image size or the final output. I will say they work well, and the final images are more than useful in most places images are used, including professional applications. EyeEm and many other apps offer great ways to make money selling stock photography taken with camera phones to the advertising world—*globally*.

When digital cameras were introduced, many photographers said that digital files would never replace film. Well, they were all wrong. This time around there are many photographers who will say that camera phones will never replace DSLRs at the consumer level. They are wrong. It is already happening. There will be thousands of us early adopters who will be saying "I told you so" in the not-so-distant future.

Final Words
The iPhone camera system, and all of its amazing apps, filters, and attachments, is great fun.

This time around there are many photographers who will say that camera phones will never replace DSLRs at the consumer level. They are wrong. It is already happening.

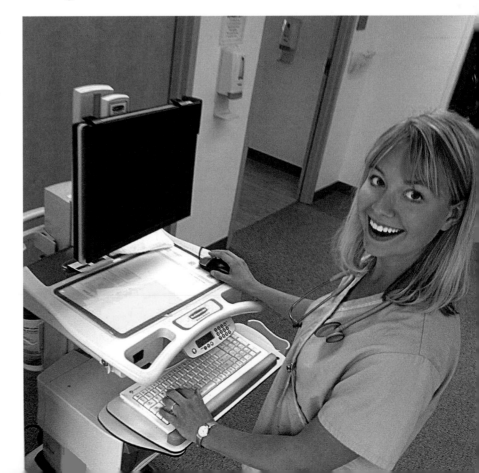

► This was the first commercial image I shot with my iPhone. I knew, that day, that it would not be my last.

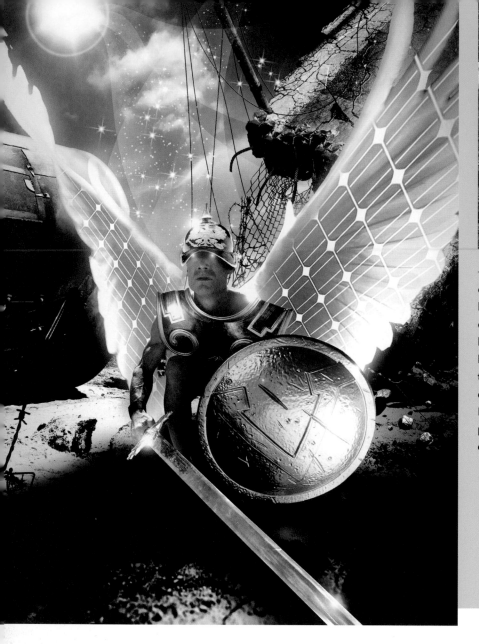

◀ This image combines my fine art and commercial photography interests. A lot of Photoshop work went into creating this image. The industrial landscape image (shown earlier in the book) and the photo of the man with the sword were straight out of the camera. The sparkles are from a Photoshop brush and the wings were part of another image I took years ago.

With a thorough understanding of the essential photographic skills, your iPhone camera, a handful of apps, and a couple of accessories, you can produce professional-quality photos.

Keep your iPhone close at hand and take chances. I love taking walks with my family in the city, suburbs, or countryside, and almost every time I am out, I have to stop and take a few photos. I encounter many of the lighting

When you discover a subject or scene that grabs your attention, move around and find the perfect angle, lighting, and composition. Give it your best shot.

scenarios depicted in this book while I am out for my adventures. You will too. When you discover a subject or scene that grabs your attention, move around and find the perfect angle, lighting, and composition. Give it your best shot. There are 100 million people competing with you to create a perfect photograph.

Take a look at the images on pages 118 through 120. As you can see, amazing photos sometimes have simple beginnings. The "before" images are presented as captured. The "after" images were manipulated by apps and Photoshop. These images prove that the iPhone can be used for advertising campaigns and professional photos in other genres.

► This photo falls into the fine art category; I made it with the intention of printing it. I was amazed by the rich colors in the iPhone capture. I was able to further enhance the colors and shading in Photoshop. My image was printed at 16x20 inches!

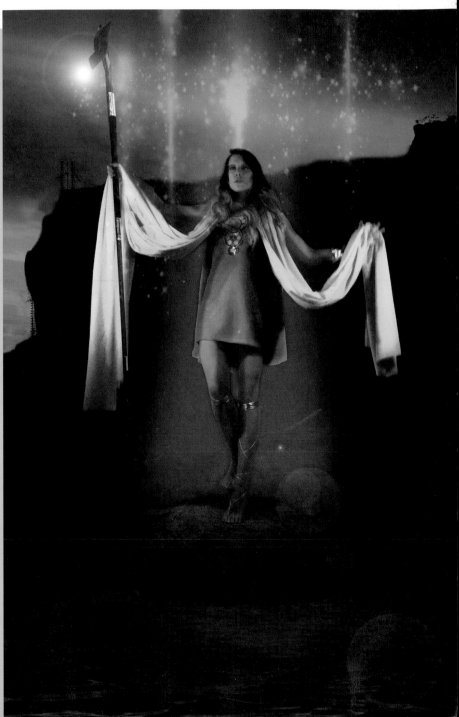

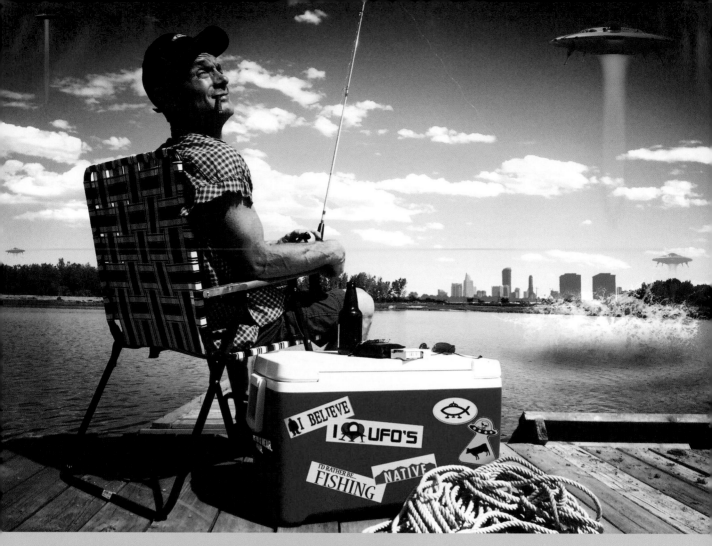

▲ This photo sends the message, once again, that the iPhone is a tool that professional photographers cannot afford to ignore. The photo of the guy in the chair is straight out of the iPhone. It served as the base image. I added all of the stickers, the UFO, the city skyline, and the water in Photoshop. The iPhone camera served the same purpose that a DSLR would have.

Index

One Wedding

Brett Florens takes you, hour by hour, through the photography process for one entire wedding—from the engagement portraits, to the reception, and beyond! *$27.95 list, 7.5x10, 128p, 375 color images, order no. 2015.*

Master Lighting Guide for Portrait Photographers, *2nd ed.*

Christopher Grey shows you how to master traditional lighting styles and use creative modifications to maximize your results. *$27.95 list, 7.5x10, 160p, 350 color images, order no. 1998.*

Fantasy Nude Photography

Rayment Kirby guides you through specialized lighting, posing, set design, and postproduction techniques that let you bring to life the images you've imagined. *$27.95 list, 7.5x10, 128p, 180 color images, order no. 2013.*

Photographing the Female Form with Digital Infrared

Laurie Klein shows you how to develop a concept, find locations, pose the model, and use natural light. *$27.95 list, 7.5x10, 128p, 180 color images, order no. 2021.*

Elegant Boudoir Photography

Jessica Lark takes you through every step of the boudoir photography process, showing you how to work with clients and design images that are more engaging. *$27.95 list, 7.5x10, 128p, 230 color images, order no. 2014.*

Magic Light and the Dynamic Landscape

Jeanine Leech helps you produce outstanding images of any scene, using time of day, weather, composition, and more. *$27.95 list, 7.5x10, 128p, 300 color images, order no. 2022.*

Shoot to Thrill

Acclaimed photographer Michael Mowbray shows how speedlights can rise to any photographic challenge—in the studio or on location. *$27.95 list, 7.5x10, 128p, 220 color images, order no. 2011.*

Classic Family Portraits

Ed Pedi walks you through the process of designing images that will stand the test of time. With these classic approaches, photos become instant heirlooms. *$27.95 list, 7.5x10, 128p, 180 color images, order no. 2010.*

Shaping Light

Glenn Rand and Tim Meyer explore the critical role of light modifiers in producing professional images of any subject, ensuring smart decisions at every turn. *$27.95 list, 7.5x10, 128p, 200 color images, order no. 2012.*

Step-by-Step Lighting for Outdoor Portrait Photography

Jeff Smith brings his no-nonsense approach to outdoor lighting, showing how to produce great portraits all day long. *$27.95 list, 7.5x10, 128p, 275 color images, order no. 2009.*

Photograph the Face

Acclaimed photographer and photo-educator Jeff Smith cuts to the core of great portraits, showing you how to make the subject's face look its very best. *$27.95 list, 7.5x10, 128p, 275 color images, order no. 2019.*

ABCs of Beautiful Light

A Complete Course for Photographers

Rosanne Olson provides a comprehensive, self-guided course for studio and location lighting of any subject. *$27.95 list, 7.5x10, 128p, 220 color images, order no. 2026.*

Step-by-Step Wedding Photography, *2nd ed.*

Damon Tucci offers succinct lessons on great lighting and posing and presents strategies for more efficient and artful shoots. *$27.95 list, 7.5x10, 128p, 225 color images, order no. 2027.*

Shoot Macro

Stan Sholik teaches you how to use specialized equipment to show tiny subjects to best effect. Includes tips for managing lighting challenges, using filters, and more. *$27.95 list, 7.5x10, 128p, 180 color images, order no. 2028.*

Portrait Pro

Veteran photographer Jeff Smith shares what it takes to start up and run an effective, profitable, and rewarding professional portrait business. *$27.95 list, 7.5x10, 128p, 180 color images, order no. 2029.*

Photographing Newborns

Mimika Cooney teaches you how to establish a boutique newborn photography studio, reach clients, and deliver top-notch service that keeps clients coming back. *$27.95 list, 7.5x10, 128p, 180 color images, order no. 2030.*

Photograph Couples

Study images from 60 beautiful wedding and engagement sessions. Tiffany Wayne shows what it takes to create emotionally charged images couples love. *$27.95 list, 7.5x10, 128p, 180 color images, order no. 2031.*

The Art of Engagement Portraits

Go beyond mere portraiture to design works of art for your engagement clients with these techniques from Neal Urban. *$27.95 list, 7.5x10, 128p, 200 color images, order no. 2041.*

Essential Elements of Portrait Photography

Bill Israelson shows you how to make the most of every portrait opportunity, with any subject, on location or in the studio. *$27.95 list, 7.5x10, 128p, 285 color images, order no. 2033.*

Boudoir Lighting

Robin Owen teaches you to create sensual images that sizzle with evocative lighting strategies that will amplify your subject's assets and boost her confidence. *$27.95 list, 7.5x10, 128p, 180 color images, order no. 2034.*

How to Photograph Weddings

Twenty-five industry leaders take you behind the scenes to learn the lighting, posing, design, and business techniques that have made them so successful. *$27.95 list, 7.5x10, 128p, 240 color images, order no. 2035.*

Tiny Worlds

Create exquisitely beautiful macro photography images that burst with color and detail. Charles Needle's approach will open new doors for creative exploration. *$27.95 list, 7.5x10, 128p, 200 color images, order no. 2045.*

Fine Art Portrait Photography

Nylora Bruleigh shows you how to create an array of looks—from vintage charm to fairytale magic—that satisfy the client's need for self-expression and pique viewers' interests. *$27.95 list, 7.5x10, 128p, 180 images, order no. 2037.*

The Right Light

Working with couples, families, and kids, Krista Smith shows how using natural light can bring out the best in every subject—and result in highly marketable images. *$27.95 list, 7.5x10, 128p, 250 color images, order no. 2018.*

Dream Weddings

Celebrated wedding photographer Neal Urban shows you how to capture more powerful and dramatic images at every phase of the wedding photography process. *$27.95 list, 7.5x10, 128p, 190 color images, order no. 1996.*

Light a Model

Billy Pegram shows you how to create edgy looks with lighting, helping you to create images of models (or other photo subjects) with a high-impact editorial style. *$27.95 list, 7.5x10, 128p, 190 color images, order no. 2016.*

Lighting and Design for Portrait Photography

Neil van Niekerk shares techniques for maximizing lighting, composition, and overall image designing in-studio and on location. *$27.95 list, 7.5x10, 128p, 200 color images, order no. 2038.*

The Mobile Photographer

Robert Fisher teaches you how to use a mobile phone/tablet plus apps to capture incredible photos, then formulate a simple workflow to maximize results. *$27.95 list, 7.5x10, 128p, 200 color images, order no. 2039.*

Alternative Portraiture

Benny Migs presents sixty edgy portraits, lighting diagrams, alternate shots, and to-the-point techniques to show you how to create stand-out portraits. *$27.95 list, 7.5x10, 128p, 200 color images, order no. 2040.*

The Speedlight Studio

Can you use small flash to shoot all of your portraits and come away with inventive and nuanced shots? As Michael Mowbray proves, the answer is a resounding yes! *$27.95 list, 7.5x10, 128p, 200 color images, order no. 2041.*

Power Composition for Photography

Tom Gallovich teaches you to arrange and control colors, lines, shapes, and more to enhance your photography. *$27.95 list, 7.5x10, 128p, 200 color images, order no. 2042.*

Nudes on Location

Overcome common obstacles to capture gorgeous nude and glamour portraits in any outdoor location. Bill Lemon provides an intimate look at what it takes to succeed. *$27.95 list, 7.5x10, 128p, 200 color images, order no. 2043.*

The Big Book of Glamour

Richard Young provides 200 tips designed to improve your relationship with models, enhance your creativity, overcome obstacles, and help you ace every session. *$27.95 list, 7.5x10, 128p, 200 color images, order no. 2044.*

The Beckstead Wedding

Industry fave David Beckstead provides stunning images and targeted tips to show you how to create images that move clients and viewers. *$27.95 list, 7.5x10, 128p, 200 color images, order no. 2045.*

Portrait Mastery in Black & White

Tim Kelly's evocative portraits are a hit with clients and photographers alike. Emulate his classic style with the tips in this book. *$27.95 list, 7.5x10, 128p, 200 images, order no. 2046.*

The World's Top Wedding Photographers

Ten of the world's top shooters talk with Bill Hurter about the secrets of their creative and professional success. *$27.95 list, 7.5x10, 128p, 240 images, order no. 2047.*

Legal Photography

Stan Sholik presents a complete reference for documenting scenes, situations, and evidence for use in civil cases—along with tips for marketing your services. *$34.95 list, 7.5x10, 128p, 155 images, order no. 2048.*

Alternative Nudes

Don't content yourself with traditional images! Yucel Yalim shows that the future of nude photography is here and full of potential for the creative photographer. *$34.95 list, 7.5x10, 128p, 180 images, order no. 2049.*

Maximizing Profits

Acclaimed business guru and photo-educator Lori Nordstrom shows portrait artists how to take the wheel and steer their businesses toward financial success. *$34.95 list, 7.5x10, 128p, 130 images, order no. 2050.*

The Essential Photography Workbook

Stephen and Joan Dantzig show how to take creative control of your images and go from taking snapshots to designing incredible images. *$27.95 list, 7.5x10, 128p, 246 images, order no. 2051.*

The iPhone Photographer

Unleash the power of your iPhone—and your artistic vision. Michael Fagans shows how the iPhone's simple controls can push you toward greater creativity. *$27.95 list, 7.5x10, 128p, 300 images, order no. 2052.*

Pricing Your Portraits

Jeff Smith's nitty-gritty guide to pricing takes the guesswork out of this daunting task, helping to ensure the profitability and long-term success of your business. *$34.95 list, 7.5x10, 128p, 140 images, order no. 2053.*

Color Master Class

Celebrity portrait photographer Hernan Rodriguez explores the power of color and presents techniques for using it to achieve better storytelling and greater emotional impact. *$34.95 list, 7.5x10, 128p, 180 images, order no. 2054.*

Boudoir Photography Cookbook

Go behind the scenes with Jen Rozenbaum as she cooks up sixty of her favorite boudoir images—in the studio and on location. *$34.95 list, 7.5x10, 128p, 180 images, order no. 2055.*

Lighting Design for Commercial Portrait Photography

Magazine covers, production stills, fashion ads—Jennifer Emery shows you how to shoot it all! *$34.95 list, 7.5x10, 128p, 220 images, order no. 2056.*

Cinematic Portraits

Acclaimed photographer Pete Wright shows you how to adapt classic Hollywood lighting and posing techniques to modern equipment and portrait sessions. *$34.95 list, 7.5x10, 128p, 120 images, order no. 2057.*

Fine Art Nudes

Stan Trampe demonstrates unexpected lighting and posing techniques, using the human form as a classic subject for his breathtaking black & white studies. *$27.95 list, 7.5x10, 128p, 180 images, order no. 2058.*

500 Poses for Photographing Full-Length Portraits

Michelle Perkins shares a host of top images from the industry's best to help you conceptualize and deliver the perfect poses. *$34.95 list, 8.5x11, 128p, 500 color images, order no. 2059.*

Portraiture Unplugged

Carl Caylor demonstrates that great portraiture doesn't require a fancy studio or a pile of pricey gear. Indoors or out, natural light can give you outstanding results! *$27.95 list, 8.5x11, 128p, 220 color images, order no. 2060.*

Epic Weddings

Dan Doke shows you how he uses lighting, posing, composition, and creative scene selection to create truly jaw-dropping wedding images. *$34.95 list, 8.5x11, 128p, 180 color images, order no. 2061.*

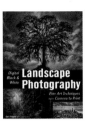

Digital Black & White Landscape Photography

Trek along with Gary Wagner as he explores remote forests and urban jungles to design and print powerful fine-art images. *$34.95 list, 7.5x10, 128p, 180 color images, order no. 2062.*

iPhoneography PRO

Take your photography to the next level—with the camera in your pocket. Robert Morrissey walks you through design and software techniques to help you shoot like a pro. *$34.95 list, 7.5x10, 128p, 200 color images, order no. 2063.*

Sexy Curves

Tammy Warnock shows you how to design sensual, joyful boudoir images of plus-size women. With these simple lighting and posing skills, flattering results are assured! *$34.95 list, 7.5x10, 128p, 200 color images, order no. 2064.*

Portraiture Unleashed

Ground-breaking photographer Travis Gadsby pushes portraiture in exciting new directions with design concepts that are sure to thrill viewers—and clients! *$34.95 list, 7.5x10, 128p, 200 color images, order no. 2065.*

Wildlife Photography

Hunter-turned-photographer Joe Classen teaches you advanced techniques for tracking elusive images and capturing magical moments in the wild. *$34.95 list, 7.5x10, 128p, 200 color images, order no. 2066.*

Infrared Photography

Laurie and Kyle Klein show you the ropes and simplify the sometimes confusing processes of scene selection, shooting, and postprocessing digital infrared images. *$34.95 list, 7.5x10, 128p, 180 color images, order no. 2067.*

CHRISTOPHER GREY'S
Lighting Techniques
FOR BEAUTY AND GLAMOUR PHOTOGRAPHY

Use twenty-six setups to create elegant and edgy lighting. *$19.95 list, 8.5x11, 128p, 170 color images, 30 diagrams, index, order no. 1924.*

UNLEASHING THE RAW POWER OF
Adobe® Camera Raw®

Mark Chen teaches you how to perfect your files for unprecedented results. *$19.95 list, 8.5x11, 128p, 100 color images, 100 screen shots, index, order no. 1925.*

BRETT FLORENS' **Guide to**
Photographing Weddings

Learn the artistic and business strategies Florens uses to remain at the top of his field. *$19.95 list, 8.5x11, 128p, 250 color images, index, order no. 1926.*

500 Poses for Photographing Brides

Michelle Perkins showcases an array of head-and-shoulders, three-quarter, full-length, and seated and standing poses. *$34.95 list, 8.5x11, 128p, 500 color images, index, order no. 1909.*

Foundations of Posing

Pierre Stephenson delves deep into one of the hardest-to-master aspects of professional photography: designing flattering, visually compelling poses. *$34.95 list, 7.5x10, 128p, 200 color images, order no. 2068.*

The Power of the Face

Celebrity portrait photographer Hernan Rodriguez explores unexpected approaches to revealing your subect's beauty and personality through their face. *$34.95 list, 7.5x10, 128p, 200 color images, order no. 2069.*

Photographing Families

Elizabeth and Trey Homan are well known for their stylish family portraits. In this book, they take you behind the scenes and reveal the techniques they rely on. *$34.95 list, 7.5x10, 128p, 180 color images, order no. 2070.*

On-Camera Flash TECHNIQUES FOR DIGITAL WEDDING AND PORTRAIT PHOTOGRAPHY

This 2nd edition of Neil van Niekerk's popular book includes updated ideas for flattering on-camera flash lighting—anywhere. *$34.95 list, 7.5x10, 128p, 220 color images, index, order no. 2071.*

The Soft Touch

To the human eye, scenes and subjects are always sharply focused, but photographers have a chance to present the world more softly and creatively. Jim Cornfield shows you how. *$34.95 list, 7.5x10, 128p, 200 color images, index, order no. 2072.*

Stylish Weddings

Kevin Jairaj shows you how to create dramatic wedding images in any setting and design shots that look like they were ripped from the pages of a fashion magazine! *$34.95 list, 7.5x10, 128p, 180 color images, index, order no. 2073.*